LAND & **LIGHT WORKSHOP**

Capturing the Seasons in Oils

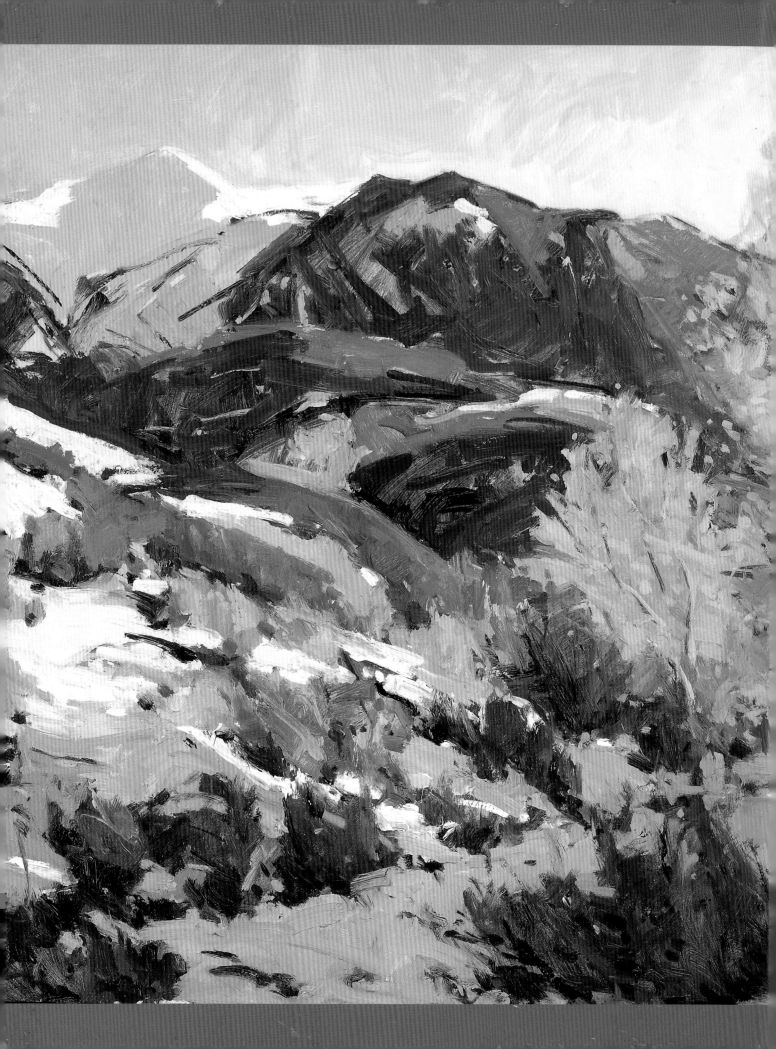

Capturing the Seasons in oils

Tim Deibler

NORTH LIGHT BOOKS
CINCINNATI, OHIO
www.artistsnetwork.com

ABOUT THE AUTHOR

Tim Deibler's dream has always been to be an artist. Art lessons from a neighbor when he was a child began his formal training. Since Tim first saw the 1956 movie *The Mountain* as a young boy, his main focus has been to paint landscapes. By the age of thirteen he was drawing the famous Matterhorn after his parents bought him the Edward Whymper book *Scrambles Amongst the Alps*. The book details Whymper's attempts to climb the Matterhorn and includes many personal sketches made by Whymper.

Upon graduating from the Colorado Institute of Art in 1979, Tim worked in the commercial art field for several years along with being a police dispatcher, ambulance technician and video productionist for documentaries and religious programming.

Tim was one of Arts for the Parks top 100 artists in 1997 with his painting of Yellowstone's "Old Faithful" being selected from over 2300 entries. This painting appears in the book entitled *Art From the Parks* released by North Light Books in November 2000. The book features 74 artists and showcases over 120 selected paintings from the past ten years of Arts for the Parks competitions.

Tim operates his own studio/gallery in southern Colorado and teaches plein air painting workshops. Many of the images in this book are available as giclée prints.

For further information you may contact Tim by e-mail at timdeibler@yahoo.com or visit his website www.timdeibler.com.

Art from pages 2–3:

November Gold • *Oil on Masonite* • *30" × 40" (76cm × 102cm)*

Library of Congress Cataloging-in-Publication Data

Deibler, Tim
 Land and Light: capturing the seasons in oils / Tim Deibler.— 1st ed.
 p. cm
 Includes index.
 ISBN 1-58180-476-8 (hc. : alk. paper)
 1. Landscape painting—Technique. 2. Plein air painting—Technique. 3. Seasons in art. I. Title.

ND1342.D474 2004
751.45'436—dc22 2004040630

Edited by Gina Rath and James A. Markle
Designed by Wendy Dunning
Production art by Lisa Holstein
Production coordinated by Mark Griffin

METRIC CONVERSION CHART

TO CONVERT	TO	MULTIPLY BY
Inches	Centimeters	2.54
Centimeters	Inches	0.4
Feet	Centimeters	30.5
Centimeters	Feet	0.03
Yards	Meters	0.9
Meters	Yards	1.1
Sq. Inches	Sq. Centimeters	6.45
Sq. Centimeters	Sq. Inches	0.16
Sq. Feet	Sq. Meters	0.09
Sq. Meters	Sq. Feet	10.8
Sq. Yards	Sq. Meters	0.8
Sq. Meters	Sq. Yards	1.2
Pounds	Kilograms	0.45
Kilograms	Pounds	2.2
Ounces	Grams	28.4
Grams	Ounces	0.04

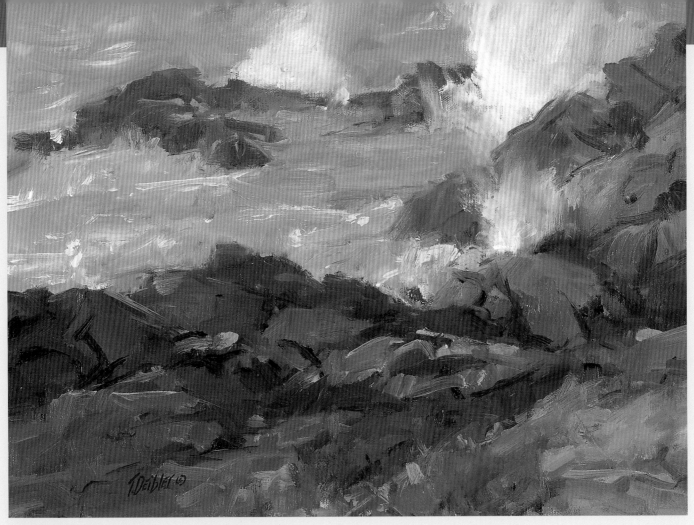

Pounding Surf • *Oil on Masonite* • *12" × 16" (30cm × 41cm)*

ACKNOWLEDGEMENTS There are so many people who have encouraged me and made this book into a reality. First, I would like to thank all of the artists who have shared their talents and knowledge with me in workshops and classes, including Scott Christensen, Michael J. Lynch, William Reese, the late Vladan Stiha and Jim Wilcox. Special thanks to my friend and teacher Quang Ho who opened my eyes to see and think as an artist. Thanks also to my painting buddies Barbara Deardorff, Jane Ford, Libby Hart, Sarah Lewis and Joe Milich. Also to Joan Hanley and Jean Shom; to John Wark of Wark Photography who shot all the 4" x 5" (10cm x 13cm) transparencies for this book; as well as the Albright family who has given me access to the most beautiful views in southern Colorado; to all the galleries that represent my work and have put up with me over the last year, especially Christine Serr and Abend Gallery who gave me my start in Denver in 1991 and still represents my work today; to my editors Rachel Wolf, James Markle and Gina Rath whose vision and hard work made it all possible, and to my Saviour Jesus Christ who created the beauty of nature for us to enjoy.

DEDICATION *I would like to dedicate this book to my parents, Don and Geraldine Deibler, and also to my wife, Mary, and children Stephen, Rachel and Sarah. They have all paid the price and made the sacrifice for me to be an artist.*

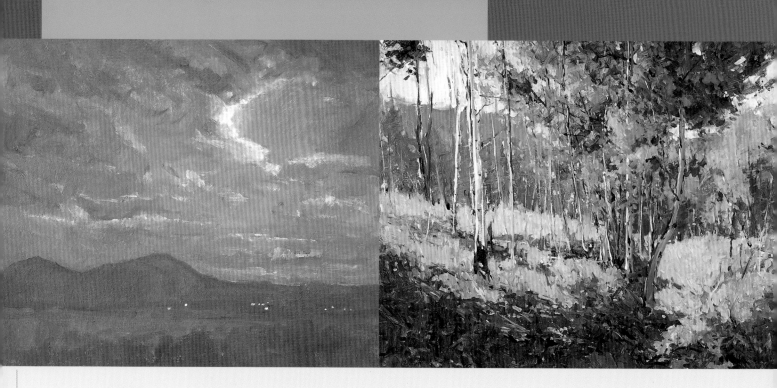

TABLE OF CONTENTS

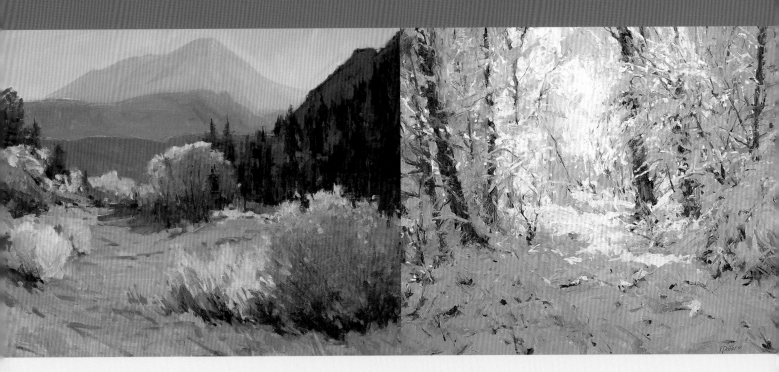

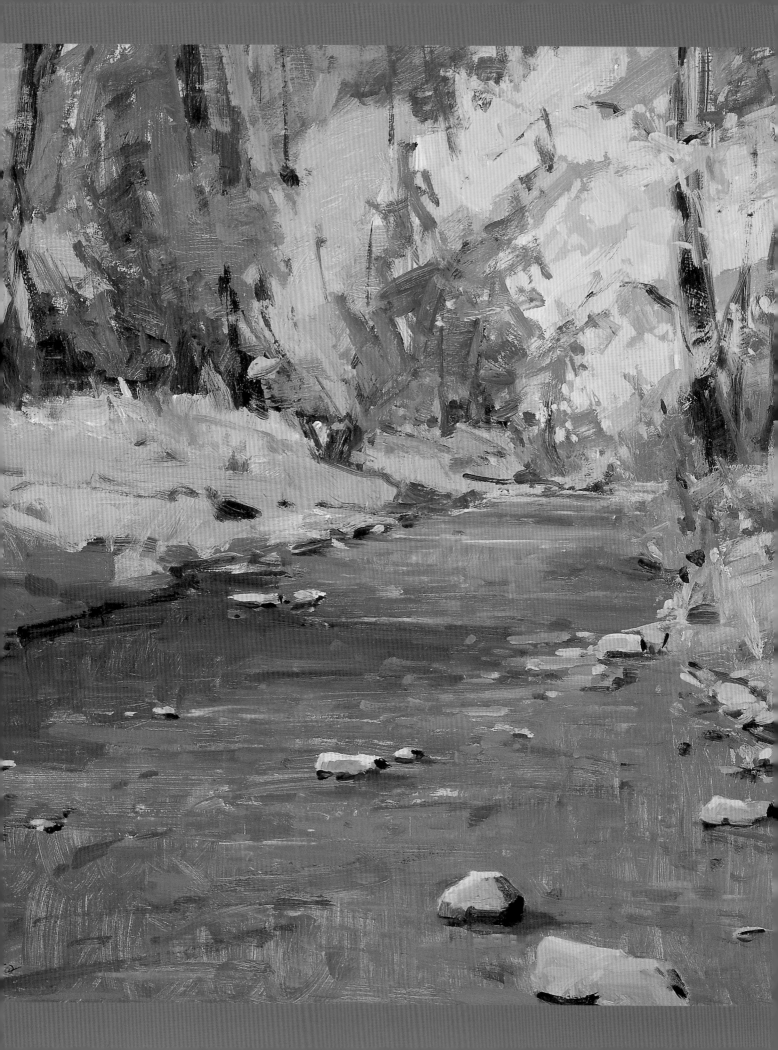

INTRODUCTION

As I travel around the block, or around the world, the paintings and sketches that I do on location become a visual diary of my artistic inspiration. A simple doodle or note hastily jotted down can ignite the spark of creativity years later and become the basis for a terrific painting. Painting goes beyond a mere representation of facts, it digs down to our very soul and is an expression of our humanity. Painting is the universal language that connects people regardless of nationality.

We all have an inner desire to create, to express ourselves. Some people do it through music, others through writing or dance. We each have a unique perspective on life; our experiences, religious convictions, personal preferences and habits color the way we see and function in the world we live in.

"Where do I start?" I hear these words echo through the studio in just about every class I teach. If not "where," then "how"? Art has both amazed and perplexed mankind for centuries and will continue to do so: from the curious onlooker thinking, "I could do that," to the frustrated artist reaching for a rag to wipe off yet another failed masterpiece. This book is designed for both the observer and the searching artist who want to understand more of the "how" of art. Through these pages you will find time-tested, solid, practical instruction that will help you in your quest to visualize for others your view of the world. Being an artist isn't just a job, it's a life-long adventure in which you are constantly putting your life experiences on canvas.

Autumn Stream • Oil on Masonite • 24" × 30" (61cm × 76cm)

1

FOUR KEYS TO GET STARTED

Beginning in this chapter we will delve into some basic but often overlooked facts or "keys" to painting. These keys will guide you in making a personal artistic statement about your vision of the world.

These keys are necessary to understand regardless of your painting style or media preference. They apply to abstract painting as much as to representational art or photo-realism. Although in this book we are painting with oils, these keys are essential even if you use watercolor, acrylic or pastels.

Morning Walk • *Oil on linen* • *14" x 18" (36cm x 46cm)*

The Four Key Elements of Painting

Just as a solid foundation is necessary for building, you also need a firm foundation on which to construct your painting. Understanding the essential building blocks of painting will make painting easier for you.

There are four key foundational elements: shape, value, color and edges. We will discuss them separately, but in practice, they are all a part of each other as they naturally work together to create the finished painted image.

Let's take a quick overview of these keys before we get more in-depth in the following pages.

I recommend that you follow along and do the exercises in this book to help reinforce these concepts in your mind. Don't worry if your finished product doesn't mirror mine. The goal of this book is to help you understand how to paint, not to paint the way I do.

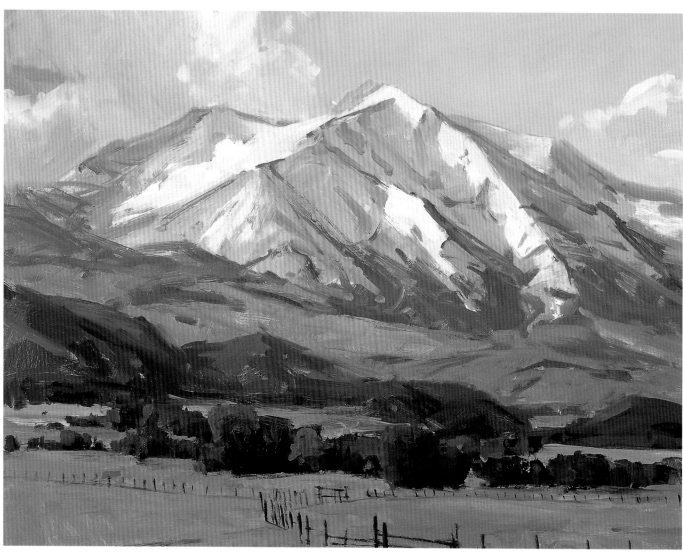

Combining the Four Keys of Painting
Whether your approach is impressionistic, abstract or photo-realistic, these four keys are applicable to any technique and subject.

Mount Sopris • 16" x 20" (41cm x 51cm) • Oil on Masonite

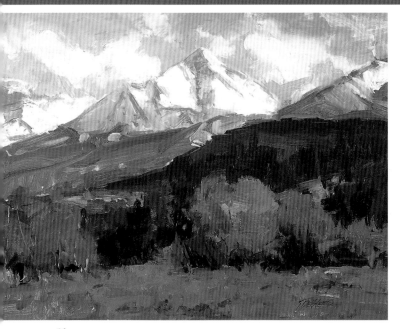

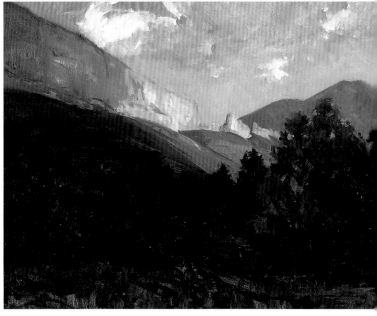

Shape

Notice in this painting of Horn Peak, located in the Sangre de Cristo mountain range of Colorado, how clear the individual shapes of the different objects are. It is easy to distinguish between the snow-capped peak and the clouds, or the different layers of tree-covered hills. You could even draw an outline around the foreground trees.

Horn Peak · Oil on Masonite · 12" x 16" (30cm x 41cm)

Value

The tonal-value range in this painting runs from the very dark foreground trees at the entrance to Magpie Canyon near LaVeta, Colorado, to the very light rock formation where the sun is shining.

Entry Into Magpie Canyon · Oil on linen · 16" x 20" (41cm x 51cm)

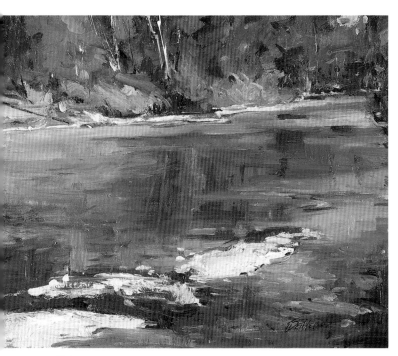

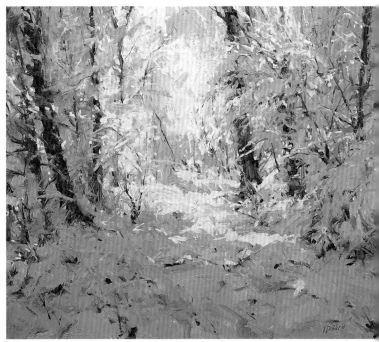

Color

In this autumn scene, the colors run wild. Bright reds next to bright greens, there are dark blues and vivid yellows; together they make an exciting, colorful painting.

Autumn River · Oil on linen · 11" x 14" (28cm x 36cm)

Edges

In this winter wonderland, the edges of the snow all but disappear as they blend in and out of each other. Distinct edges only appear in the darker trunks of the trees.

Through the Woods · Oil on Masonite · 24" x 30" (61cm x 76cm)

Key Element I: Shape

Intellectually, we define our world by shape. We think in terms of pictures rather than words. If I asked you to visualize your mother, do you see the letters m-o-t-h-e-r in your mind or do you have a mental image of your mother? What if I said to visualize an elephant? The image can be vague or full of detail, but the essential shape is what we see and think. For instance, if you were on a busy street corner and saw a friend walking down the other side of the street, do you recognize them because you can see what color their eyes are, or because they have a unique shape that registers in your mind as being a certain friend?

In painting, I list shape as the first key element simply because no matter what kind of mark you make with a pencil or brush, you create a shape. It might be a thin line or a wide brushstroke, but it has dimension.

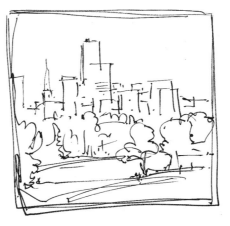

Indicate Basic Shapes
Line drawings are a great way of recording important information quickly. Drawing complex scenes such as buildings or cityscapes by indicating only the most basic shapes and angles will help you to more easily visualize and compose your painting.

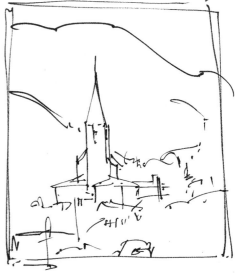

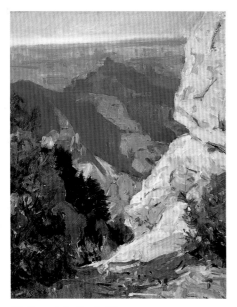

Distinguish Each Shape
Keep shapes distinct. Even as objects recede into the distance, their individual identity should not be lost.

From the North Rim · *Oil on linen* · *18" x 14"* *(46cm x 36cm)*

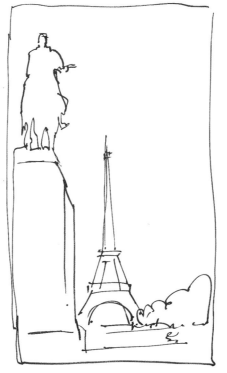

Drawing Shapes
This drawing took less than one minute. Can you identify this famous landmark? I'll give you a hint—it's in Paris, France. Shapes can be drawn with just an outline, a contour drawing absent of value (except for the value of the media used), and still be recognizable. Your perception of shape is one of the major factors in determining your painting style. How much detail is necessary for you to make your statement?

Recognizing Shapes Exercise

Just as we train our physical body for fitness, we need to train our mind to think artistically. By training our mind, we will be able to rapidly draw our subject with greater accuracy. A good shape can carry the idea without any detail.

Select a photograph, and see if you can see the geometric structure in it.

Shown below is a photograph of a grist mill. As you view a subject such as this one, simplify it into the obvious shapes that you see. Do you see a square, a rectangle, a circle or maybe a triangle? Draw the shapes quickly, and in a few seconds the recognizable image will appear.

This is great to do anytime and anywhere you have a few seconds. Carry a sketchbook with you, get into the habit of sketching and notice how your work improves.

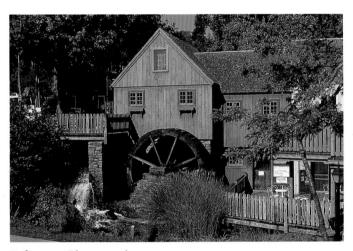

Reference Photograph

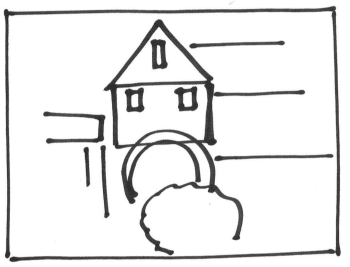

Breaking Down a Photograph Into Simple Shapes
Compare this shape drawing with the photo of the grist mill and see how clear and obvious the shapes are. Not all landscapes will be as clear or as geometrical as this, but with a little practice, you will easily see the underlying shapes hidden within.

Composing With Shapes

Another part of the shape category is composition, or composing your paintings. Composition is simply the arrangement of your subject on canvas. There have been entire books written on this subject alone that are well worth the time to read.

Where you choose to divide the canvas is the first step in conveying your idea to the viewer. Is the horizon high or low? Is the subject near or far away? Big or small? Although there are many different ideas regarding placement, it really all comes down to what you want. Intuition plays a big part in painting, especially in the area of color and composition. Sometimes you just feel something needs to be in a certain spot, or needs to be a certain color even though it doesn't correspond with your

reference material. Please notice that I said reference material. Painting from nature isn't about trying to copy literally. It's more about your emotional reaction to what you are seeing and experiencing. The goal is to share the experience—put the viewer in your shoes. Keep your paintings emotionally charged; personal expression and vision are what make good art.

There are many different compositional formulas and ideas that are popular today. Many have stood the test of time, while others are more modern and daring. Let's look at some common compositional arrangements that are particularly useful in landscape painting. The following examples show six of the more obvious compositions prevalent in nature.

Keep in mind these are only a few of the many possible arrangements. The most important thing is to trust your instinctive feel for balance and arrangement. Since we all have a slightly different feel for things, I encourage you to use the ideas presented here to inspire you.

Making your own personal artistic statement is more important than following a rigid set of rules.

Suggested Reading

I would highly recommend reading the book *Composition of Outdoor Painting* by Edgar A. Payne (Payne Studios).

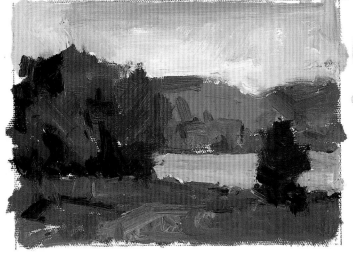

Steelyard Composition
This example is commonly referred to as a steelyard composition (a steelyard is a balance scale consisting of a beam balanced on a fulcrum with sliding weights of differing sizes). Put simply, it is a large mass at one side of the canvas balanced by a smaller mass on the other side. The center of interest is usually near the large mass or, as in this case, it is the large mass of trees on the left.

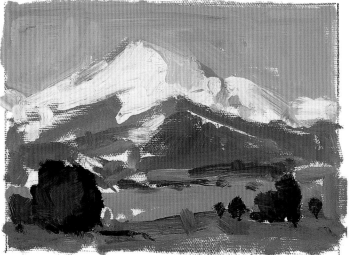

Triangular Composition
The snow-capped peak along with the dark bushes at either side near the bottom form a clear triangle composition. The triangle may not be as obvious in all paintings and, if centered too exactly, it can become rather static and symmetrical. Keep in mind the close relationships of the different types of compositions; more than one may be at work in your final design.

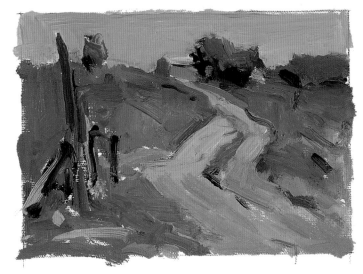

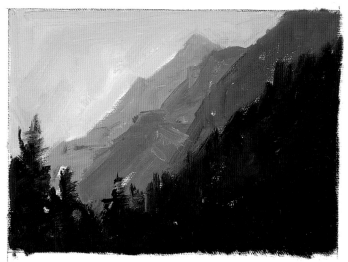

S-Curve Compositon

The S-curve is one of the most obvious and easily understood of all the different compositional arrangements. Who hasn't seen the classic river winding into the distance? In this example, we have a dirt road winding up to a house on the top of the hill.

Balance Diagonals With Verticals

If not for the dark vertical trees on the lower left, the strong diagonal prevalent in this sketch of Pyramid Peak would have the tendency to lead you right out of the picture. Make sure when you use this dynamic type of composition that you use some verticals to break the line and keep the viewer inside the picture.

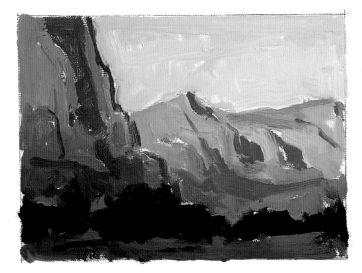

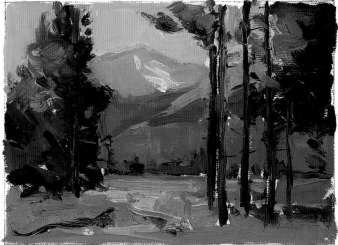

L-Shaped Composition

An L-shaped composition is particularly useful for creating depth in painting landscapes. A strong vertical foreground or middleground object extending near the top or out of the picture plane is an effective tool in establishing size relationships, thus creating depth. Typically, in an L-shaped composition the main focal area will be on the horizontal line near the upright element.

If you were to place the focal area on the opposite side of the canvas it becomes a form of the steelyard composition (see page 16).

U-Shaped Composition

The U-shape is great when trees or other tall objects are in the composition. By running the treetops or other tall objects off the canvas, you create a type of window for the viewer to look through. If you connect them at the top, you would then have a tunnel-type composition. By varying the size of the masses on each side, it closely resembles a steelyard. By framing the distant mountain with trees, I have made it the center of interest.

Key Element II: Value

Value is the next major key to any successful painting. Value is the relative lightness or darkness of an object as it would relate on a scale from black to white. Although there are hundreds of actual values in nature, due to the limitations of paint, it is best for the artist to group these values into a much smaller range. Fewer values in a painting will create a stronger statement and make the piece more readable for the viewer.

Through value we can show the three-dimensional qualities of our subject, as well as distance and atmosphere. Unless the value of the color is correct, color will never carry the message.

Value is the most important element we have to convey the truth of nature—even more so than color.

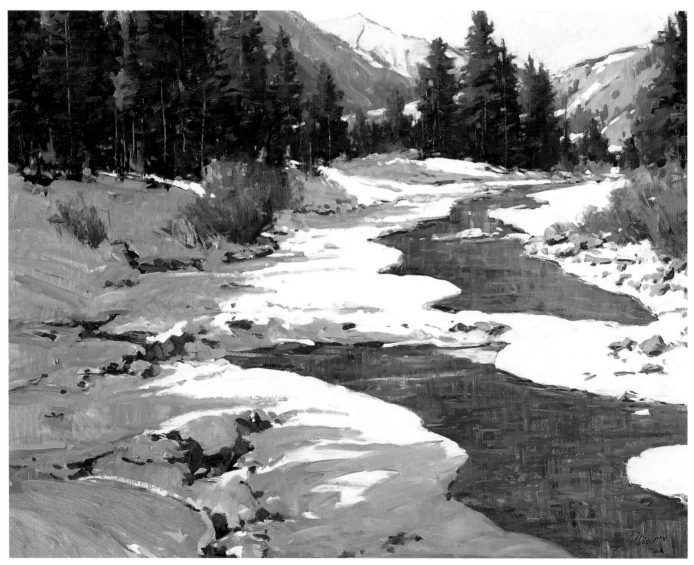

A Full Range of Values
A full range of values, from the white of the snow to the darks of the pine trees is evident in this wintry scene.

Ten Mile Creek • *Oil on Masonite* • *30" x 40" (76cm x 102cm)*

Value Scales

A good way to help solidify values in your mind is to take some time to create several different value scales. Here you can see that I have scales ranging from nine values down to just three values. Many of the best paintings in history have been created with just three or four values.

My value scales were made with oil, Prismacolor markers and pencil. To make your own, just draw 2-inch (51mm) squares on a piece of canvas or gessoed Masonite. Having an odd number of squares will make it easier to find the middle value.

Start with white in square number one and black in the last square. Mix black and white together equally to find the middle gray, then fill in the squares in between by mixing the middle gray with the black for the halfway value on the dark end of the scale. Then mix the middle gray with white for the halfway value on the light end of the scale. Try making the value scales in several different mediums such as acrylic, watercolor, charcoal, pencil and pastel.

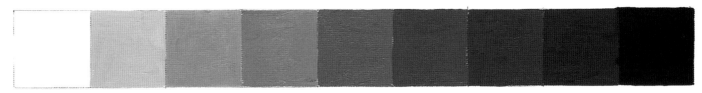

Nine-Value Scale in Oil

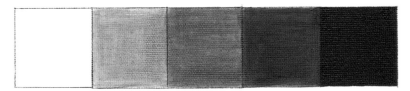

Five-Value Scale in Marker

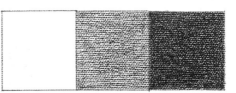

Three-Value Scale in Pencil

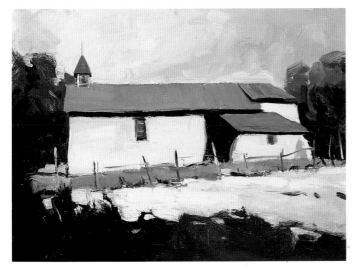

Capture Strong Contrast With Values
Clear sunny days create very definite shadow areas resulting in hard, distinct edges. These differences are indicated through value changes. When the sun is extremely bright, shadows become very dark. Dig out some of your old black-and-white photos and see if you can determine if they were taken on a sunny or cloudy day. One sure giveaway would be if everyone in the picture was squinting because the sun was in their eyes. I think you will find that black-and-white photos can be a huge help in learning to see value relationships.

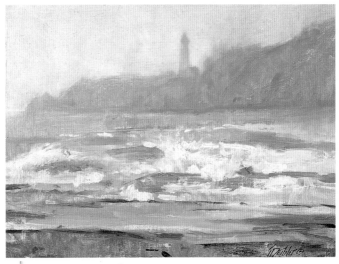

Using Similar Values
The inclement coastal weather creates soft edges and similar values. Notice how forms lack detail; do you see the lighthouse on the distant cliff? On an overcast day all the values of a landscape are relatively close together because of the lack of any strong sunlight.

The Four Value Planes

Nature presents us with four differing value planes. Since the sky is the source of our light, it most often will be the lightest value in a landscape painting. A few exceptions to this would be bright sun on snow or water, or the sky could be darker due to certain weather conditions. The horizontal ground plane would be the next lightest because it receives the most light, being most perpendicular to the source of light, the sky. Slanted planes, such as mountains, would receive less light and would be third in value. Finally, upright masses receive the least amount of light and therefore would be the darkest value.

The sky being the source of light is usually the lightest value.

Sunlit snow is an exception and becomes lighter than the sky.

Slanting planes receive less light than the ground and are darker in value.

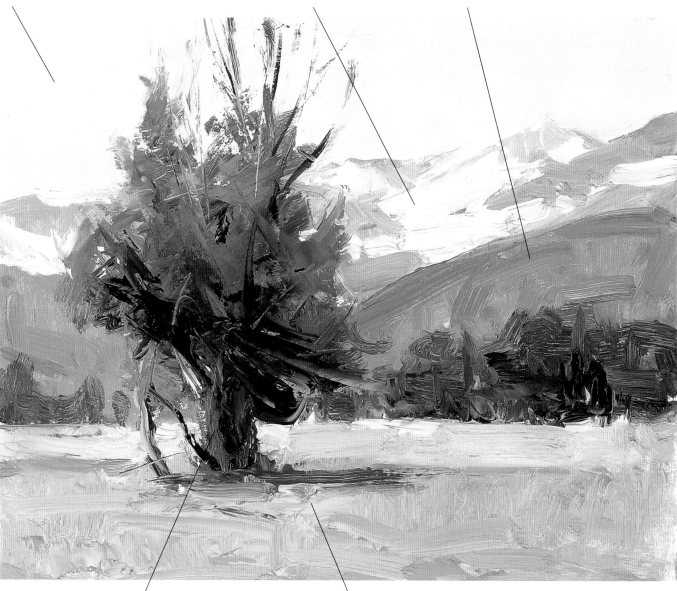

Verticals, such as trees, receive the least amount of light from the sky and are darkest.

Flat ground planes receive the most light from the sky, making them lighter than other planes.

Dominant Value Key

After having selected a subject and determined its value, the next important consideration is the overall value tone of the painting. What do I mean by that? By composing with values you can design a pleasing, unequal distribution of values over your canvas. The way to do that is to have one value, either the light, medium or dark, be the most dominant. The dominant value takes up the largest amount of space in the composition, so much in fact that the other two values together don't equal its amount of space. Also, the two supporting values should not be equal in their distribution of space as they might appear static.

The following black-and-white abstract paintings will help to make this clear.

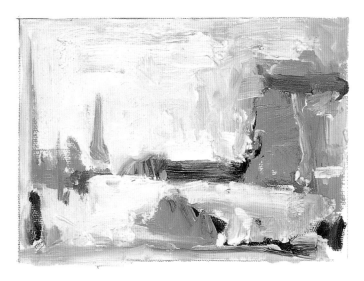

Dominant Light Value
The light values clearly dominate the surface area of this composition, giving it a sunny or cheerful feeling. The medium value adds some dimension to the scene and uses considerably less space than the light value. The black uses very little space, it is used just as an accent.

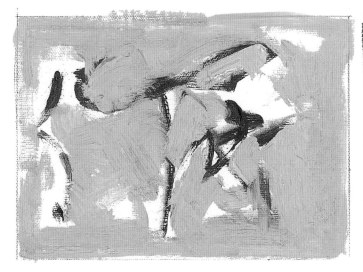

Dominant Medium Value
In this second illustration the medium value takes over, leaving only a small amount of space for the dark and the light values. There is almost an equal distribution of dark and light, and had it not been for the expressive and lively shapes, those areas might appear static.

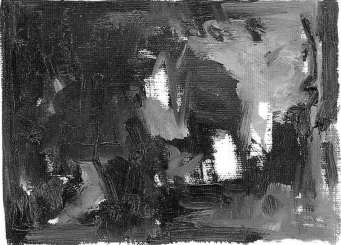

Dominant Dark Value
Now it's time for the dark value to set the mood. With this heavy distribution of dark value and a tiny distribution of light value, this almost looks like a night scene with a light shining in some windows. The medium value using less space than the dark again adds dimension to the scene. The large area of dark value makes the small area of light seem even lighter. With so much dark it only takes a little light to steal the show.

Creating Mood With Value

Selection of the dominant value helps to set the mood, or key, of a composition. Paintings are usually classified as either high-key, middle-key or low-key. *High-key* paintings are based on the lighter values of the scale, whereas *middle-key* paintings utilize the entire value scale. *Low-key* paintings use from the middle-value range down to black. However, you will find it beneficial to use a few strokes of contrasting value in the high-and low-key pictures as accents.

Everything in nature is seen in relationship to everything else. Getting value relationships right by considering the landscape as a whole will make your painting look believable. And understanding how to manipulate value will help you to achieve the feeling you're after, even if nature isn't handing you a perfect picture.

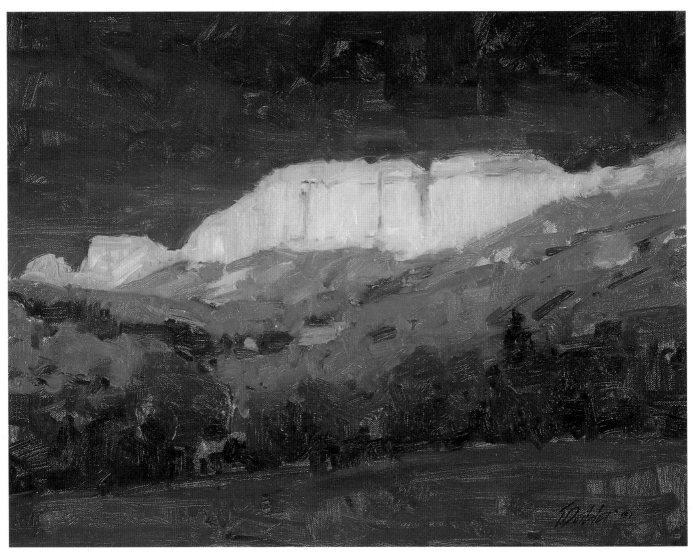

Setting Mood With Contrast
This kind of dark, brooding sky is typical of a late evening thunderstorm. Notice how much drama is created by placing extreme value contrasts next to each other.

Evening Storm • *Oil on linen* • *12" x 16" (30cm x 41cm)*

Continuity Creates Tranquility

By shifting the values of this painting into a narrower value range, I have created a more tranquil mood. Although the sky color and atmosphere may suggest an evening rain, the drama that is obvious in *Evening Storm* (previous page) is gone because of the less-intense light on the rock wall.

Fading Light · *Oil on linen* · *8" x 10" (20cm x 25cm)*

High-Key

The feeling of warm sunlight shining in the background and through the autumn foliage places this painting in the high-key category. If you squint at this painting, you will notice the top two-thirds or more is relatively light in value. The darkest area at the bottom is still mainly in the middle-value range. A few dark accents help to complete the value range without competing against the light, sunny feel.

Golden Aspen • *Oil on Masonite* • *40" x 30" (102cm x 76cm)*

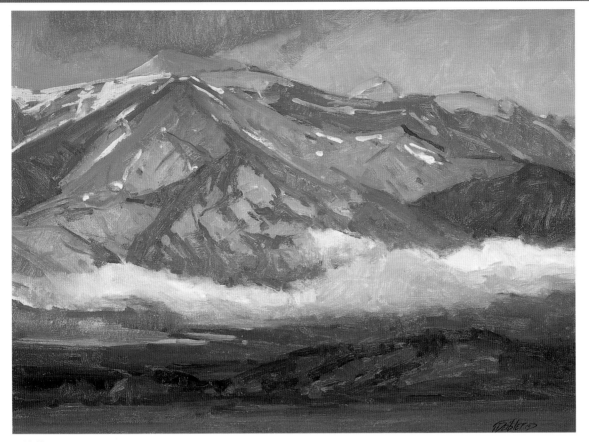

Middle-Key

A full range of values has been used in this piece, but the middle values are the most dominant. Because of the cloud cover, the morning sun is able to strike only part of the mountain leaving the rest in a middle-value shadow. The ground plane is still very dark because of the low angle of the sun and the lower clouds.

April Morning on Greenhorn · Oil on linen · 18" x 24" (46cm x 61cm)

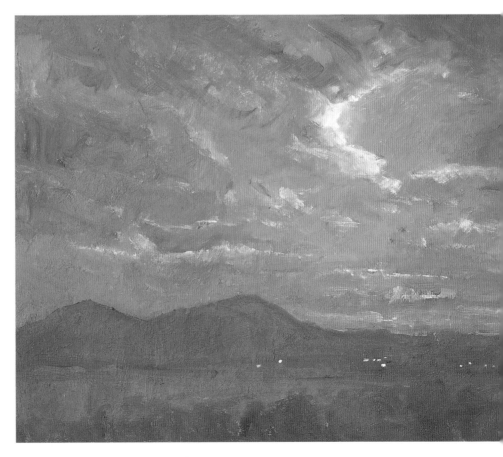

Low-Key

This night scene also shows a full range of values but the most dominant are the middle to dark values. Even in this moonlit scene, the slanted planes of the distant mountain are receiving less light from the moon than the horizontal ground plane.

3:30 AM · Oil on Masonite · 16" x 20" (41cm x 51cm)

Composing With Values

■ If you stay at a specific location for a given length of time, nature will present you with a varying array of options for a good painting. As the light changes, so do the values. Whether from a passing cloud, or just passing time, all values are determined by the light falling on them.

This demonstration will focus on some of the different choices you have as you are painting. Choose one of your favorite landscape photographs or, if possible, go to a favorite place. By composing with shapes and value, you can more effectively catch the spirit and the truth of nature. Try using just two values plus the white of your paper or canvas. You might try using a soft pencil like a 6B, gray markers or charcoal. You can even do them in oil as I did, using just black and a middle-value gray on white canvas.

In this series of value sketches, different moods are created just by shifting the values around. The location and composition remain the same, but now I am composing also with values. If you want your paintings to be believable and realistic, your use of value is more effective than the amount of detail added.

Hopefully you have begun sketching shapes everywhere you go. If so, begin to add some values to your drawings and watch a whole new world open up for you artistically.

One of the best compliments I ever received was when someone walked into my gallery, stared at one of my paintings for awhile then said, "I get the same energy from this painting that I get from nature."

MATERIALS

Reference Photo

9" x 12" (23cm x 30cm) Sketchbook or canvas

BRUSHES
No. 4 bristle flat

OTHER SUPPLIES
6B pencil or charcoal

Grey Prismacolor markers, 20%, 50% and 90%, or black and white paint

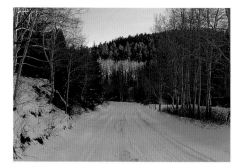

Reference Photograph

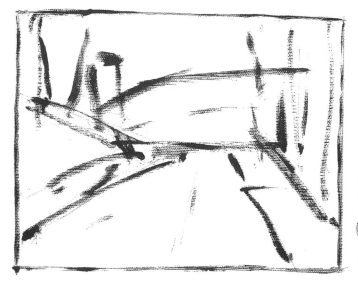

 Paint Three Quick Sketches
Use your reference photograph to paint three identical sketches on one canvas. Keep the sketches small, simple and quick.

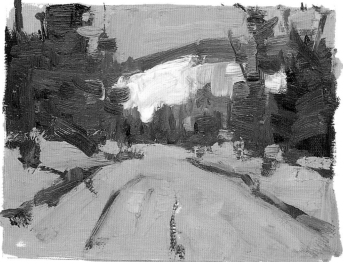

2 **Establish the Values**
On your first sketch, establish the values as they appear in the photo.

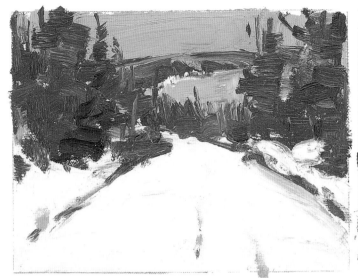

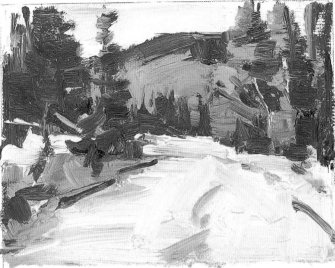

Shift the Values

3 Now change the arrangement of values in your second sketch. For example, if the foreground is in shadow in the photo and the background in sun, rearrange it so the foreground is in light and the background is in shadow.

Shift the Values Again

4 In your third and final preliminary sketch, try to rearrange the values one more time. Here I have lightened the sky and kept the background dark.

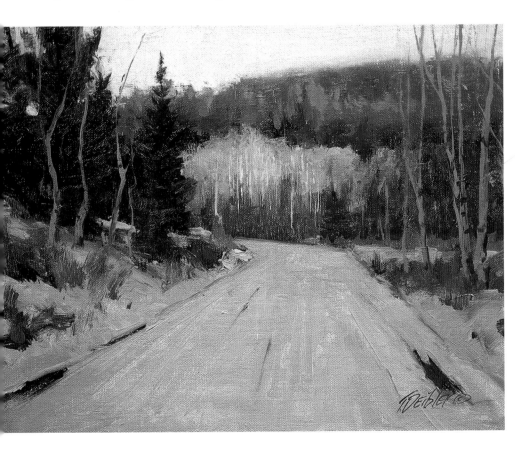

Contrast

I kept the lighting for this painting, *Pass Creek Road*, the same as in the original reference photo. I remember driving this snowy road one evening after helping some friends who were building a new house. The final warm rays of light were hitting the trees and would be gone in a few moments. What I wanted to portray in this painting was the contrast between the warmth of the sun and the coldness of a winter evening.

Pass Creek Road · *Oil on linen* · *9" x 12"*
(23cm x 30cm)

Key Element III: Color

There are countless books and theories on color and its use in fine art. Many do more to confuse the issue rather than to clarify it. My intention is not to rewrite color theory, but to put it in simple terms that will be most applicable to you as an artist.

I often hear artists talk about light. How light in one part of the world is different than in another. The fact is, the light source doesn't change. The sun that shines in Venice, Italy, is the same sun that shines in Santa Fe, New Mexico. So what is it that causes the light to appear different?

The change occurs when light enters our atmosphere. Since different colors of the spectrum bend at different angles, they scatter differently. Simply, the difference in the quality of light around the country and around the world is a result of different atmospheric conditions. It may be humidity or lack of humidity, the altitude, the sun's position in the sky, dust, or even pollution. The more atmosphere and suspended particles the light has to travel through, the more of its energy is lost.

At noon on a clear day, the sun has a relatively thin layer of atmosphere to penetrate and the sun appears a yellow-white. As the sun sets, its light must travel farther through the atmosphere before it gets to you. Colors with shorter wavelengths, such as blue, green and violet, are scattered, but red, having the longest wavelength, remains; thus creating the red glow that we see at sunset.

What we are seeking to do as artists is to paint the effects of light striking a subject. Sight is possible because of the light that is reflected from objects around us. Everything we see is a reflection of light. Therefore the local color of objects will differ based upon the color of light that illuminates them.

Without light we don't see color, and the color of sunlight will differ under different circumstances. This eliminates the plausibility of having color formulas or recipes for different objects. The color of a rock differs with the color of the light shining on it, as does the color of a tree, or a house or any other object we see in nature. These same qualities of light also affect the values we see and our perception of edges.

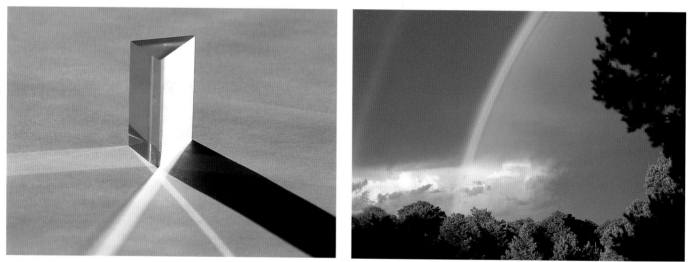

Glass Prism

The color of objects that we see is a by-product of light falling on that object. Without light, nothing has color. In 1672 Sir Isaac Newton discovered that white light could be split into specific colors by passing it through a prism. The colors are red, orange, yellow, green, blue, indigo and violet. Since each color has a slightly different wavelength, striking an angled surface causes them to bend at different angles. We can also see this phenomenon in nature when rays of sunlight are bent by atmospheric water particles, thus creating a rainbow.

Pigments

Understanding some of the characteristics of light is just the beginning. Since we are painting with pigment rather than light waves, let's take a close look at the tools we use in our attempt to depict light.

There are many pigment colors available for the artist today. With so many choices, how do we know which to use? The best advice would be to keep it simple. When painting landscapes, we essentially have two light sources we are dealing with. The major light source is of course the sun; however, the cool blue of the sky acts as a secondary source, illuminating the landscape that is not directly influenced by the sun. So we have a warm light source and a cooler, secondary light source. Many studio painters use the cool light from north-facing windows as their light source. In effect, this sets up the opposite warm-cool relationship. In this studio environment the cool north light creates warm shadows, whereas outside, the warm light creates cool shadows.

In paint form, the primary colors are red, yellow and blue. From these three colors it is possible to mix an endless array of other colors. For example, red and yellow mixed together make orange; blue and yellow make green, and red and blue make violet. These mixtures made from two primary colors are called secondary colors. Essentially these six colors, three primaries plus the three secondaries, are the same colors that comprise our natural daylight. Choosing only the three primary colors would certainly simplify things; however, the perfect primary yellow, red or blue doesn't exist in paint. Each color leans either to the warm side or the cool side of its color family. In other words, a yellow can be a warm yellow having some red in it, or a cool yellow with some blue in it.

Since we are always dealing with two separate light sources outside, one warm and one cool, it would stand to reason the best choice is to select a warm and cool of each primary.

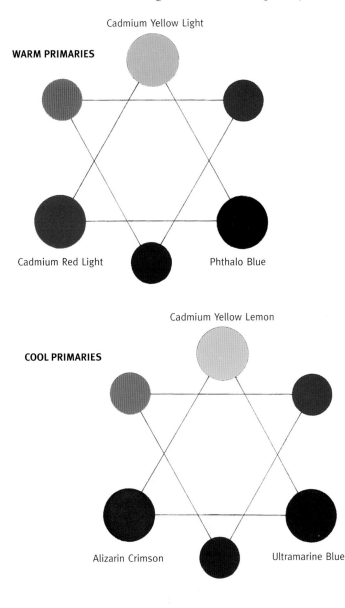

WARM PRIMARIES

Cadmium Yellow Light

Cadmium Red Light

Phthalo Blue

COOL PRIMARIES

Cadmium Yellow Lemon

Alizarin Crimson

Ultramarine Blue

Warm and Cool Primary Color Wheels

These color wheels are each made with three primaries: one wheel uses warm colors, the other uses cool colors. The differences in the secondary colors that these two wheels produce is amazing. The violet made in the warm primary palette is so neutral it is almost black. The reason is that both Cadmium Red Light and Phthalo Blue have yellow in them, and yellow—being the complement to violet—dulls the mixture, even though yellow is not an added color. The same principle is at work in the cool palette's mixture of orange. Alizarin Crimson and Cadmium Lemon have blue in them; therefore, when mixed to make an orange, the blue factors in as the complement and keeps the mixture from being a pure brilliant orange.

The warm primaries used here are Cadmium Yellow Light, Cadmium Red Light and Phthalo Blue. The cool wheel is made with Cadmium Yellow Lemon, Alizarin Crimson and Ultramarine Blue. Ultimately, you will have to experiment with different colors to find the ones that work for you. We all see color a little differently and everyone's artistic vision differs.

Personally, I tend to use a lot of orange, so for convenience I've added the tube color of Cadmium Orange to my palette. Instead of using two reds, I have chosen just one, Naphthol Red Light, which falls somewhere between the warm Cadmium Red Light and the cooler Alizarin Crimson. Since Naphthol Red Light is neither too cool nor too warm, it mixes nicely in either direction.

Color Charts Simplified

You can create a variety of colors from just a few chosen ones. Of course, there are many variables to the final results, as well as endless variations.

I keep my palette simple; I use Phthalo Blue, Cadmium Yellow Light, Cadmium Orange, Naphthol Red Light, Ultramarine Blue and Titanium White. I think you will be amazed at how many colors and values you can achieve with this palette.

A good way to familiarize yourself with these colors is to make a chart like the one on this page. You might try adding a touch of white to the right side of each mixture to see how the color of the mixture changes when lightened. Or make an entirely separate chart with each color lightened with white. You could even make additional charts from each of the mixtures by adding increasing amounts of white.

Color Chart

The advantage to a chart like this is that it shows every color on your palette mixed with every other color without any repetition. To make your own chart, all you need is a pencil, a ruler, your paints and a piece of gessoed Masonite or canvas. The first thing you need to do is count how many colors there are in your palette. Make enough 2-inch (51mm) squares down the left side of the Masonite or canvas for every color you use. Make the same number across the top row. Every row on down you will need one less square.

Fill the squares down the left side with pure colors straight from the tube. Then, mix the color in the top square (your first color) with the color under it and place it on the top row beside the first color. Now mix your first color with the next color down (your third color) and place it in the third spot on the top row. Continue mixing your first color with each of the colors all the way down the left side and place each mixture in the next spot on the top row. Following the same pattern, with your second color, mix it with each of the colors under it and place the mixtures on the second row. Continue mixing the remaining colors in the left column with the colors underneath them and placing them in their respective rows. When you get to the final color, you're done! It has already been mixed with every other color.

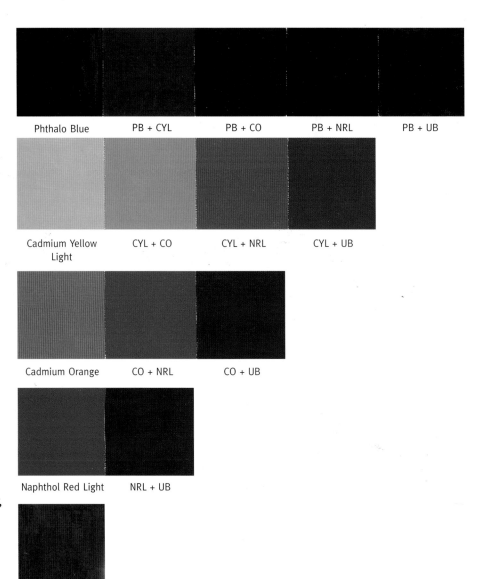

| Phthalo Blue | PB + CYL | PB + CO | PB + NRL | PB + UB |

| Cadmium Yellow Light | CYL + CO | CYL + NRL | CYL + UB |

| Cadmium Orange | CO + NRL | CO + UB |

| Naphthol Red Light | NRL + UB |

| Ultramarine Blue |

Winsor & Newton Cadmium Scarlet	Utrecht Cadmium Red Light	Winsor & Newton Winsor Red	Utrecht Naphthol Red Light	Utrecht Quinacridone Red	Winsor & Newton Alizarin Crimson

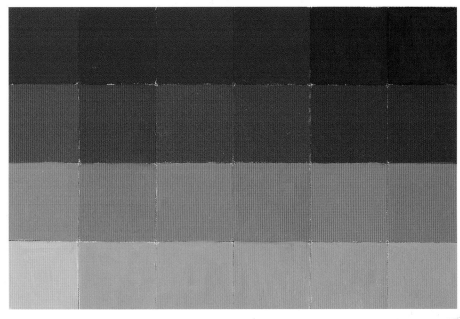

Mixing With White

I took some of the common reds available and mixed each with white. This is a good way to compare different colors in the same family to determine if they are warm or cool.

Permalba	Grumbacher	Winsor & Newton	Utrecht

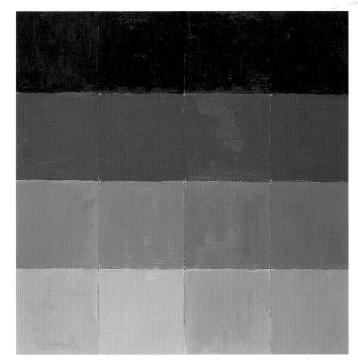

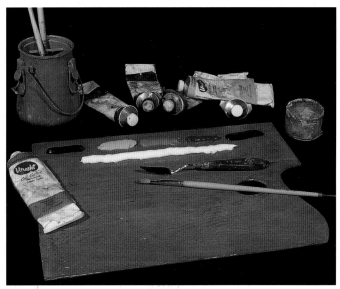

Compare Manufacturers

It is also a good idea to keep charts of certain colors from different manufacturer's like this one of Ultramarine Blue. You may notice some extreme differences as you compare different brands. You could expand this chart to include the many varieties of Ultramarine Blue such as Light, Deep and French Ultramarine. Training your eye through experience is your best teacher.

My Palette

These are the choices I have settled on for my palette. From left to right, Phthalo Blue, Cadmium Yellow Light, Cadmium Orange, Naphthol Red Light, Ultramarine Blue and Titanium White. I also carry a tube of Cadmium Yellow Lemon when Cadmium Yellow Light is too warm for a particular situation. I prefer Utrecht oil paints, but over the years I have tried just about every major brand available. My only word of caution would be to avoid any student-grade paints and any colors that have the word "hue" after the color name.

Color Temperature

As mentioned earlier, each tube color leans toward either cool or warm. So to further help you understand how color mixing works, I have taken each of my warm and cool blues and mixed them with each of my yellows.

I encourage you to also try mixing different reds and blues together to see the different violets you come up with, or different reds with yellows to see the variations in oranges. Taking the time to experiment now will save you countless hours of frustration later when you are trying to mix a certain color.

Cadmium Yellow Lemon Ultramarine Blue Cadmium Yellow Light

Cadmium Yellow Lemon Phthalo Blue Cadmium Yellow Light

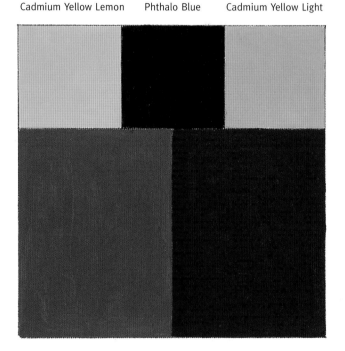

Mixing to Determine Temperature
When I mix Ultramarine Blue with Cadmium Yellow Light, the result is a less vibrant green than mixing Ultramarine Blue with Cadmium Yellow Lemon. The reason is that both Ultramarine Blue and Cadmium Yellow Light have a touch of red in them, and since red is the complement to green, it grays or neutralizes the green.

A More Vibrant Green
When you mix Phthalo Blue and Cadmium Yellow Lemon you get a very vibrant green because of the absence of red in both colors. The green is not quite as bright when mixed with Cadmium Yellow Light (which contains a slight touch of red).

Color Harmony

Nature presents opportunities for color choices that we would never dream of in the studio. Landscape painters most often take color harmonies directly from nature. Our job, however, is not to necessarily just copy nature, but to interpret it. Following is some helpful information about color combinations that harmonize. Use these to enrich your color palette and expand your creativity.

Using a Limited Palette

Using a limited palette is the easiest way to create natural color harmony in your work. Since all mixtures are made with the same few colors—a combination of every color on your palette—they naturally harmonize.

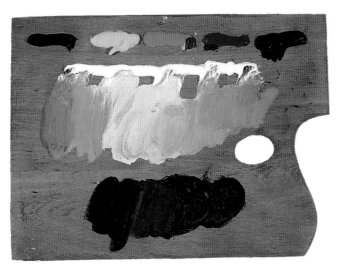

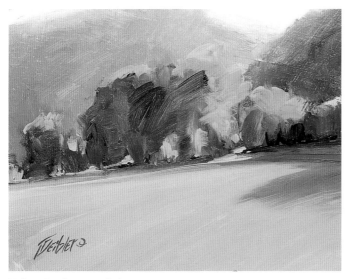

Using Analogous Colors

An analogous theme of yellows, greens and blues was used to create this light-filled landscape. To use an analogous theme, you start with any of the primaries and use the colors next to it on the color wheel (usually two to five colors) in either direction. With a triadic theme, any three colors, spaced about equally on the color wheel, are used.

Afternoon Sunlight • *Oil on Masonite* • *5" x 7" (13cm x 18cm)*

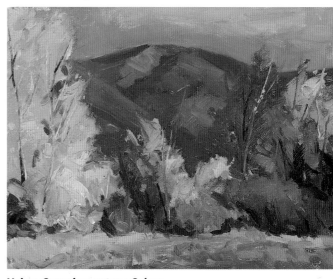

Using Complementary Colors

The soft purples of the background hill act as a perfect foil for the brilliant yellows of the autumn foliage. Complementary themes focus on any one of the complementary pairs, blue and orange, yellow and violet or red and green.

Autumn Gold • *Oil on linen* • *9" x 12" (23cm x 30cm)*

33

Painting With Complements

I encourage you to try a painting using complementary colors. In this exercise, I chose a pair of complements, blue and orange, and did two paintings of the same harbor scene emphasizing a different complement in each painting. I used a medium-sized canvas and a medium-sized brush to keep my painting loose. The dominant color drastically alters the mood of the two paintings even though they both have a monochromatic feel.

You might try expanding on this idea and do the same scene with some of the other color themes also.

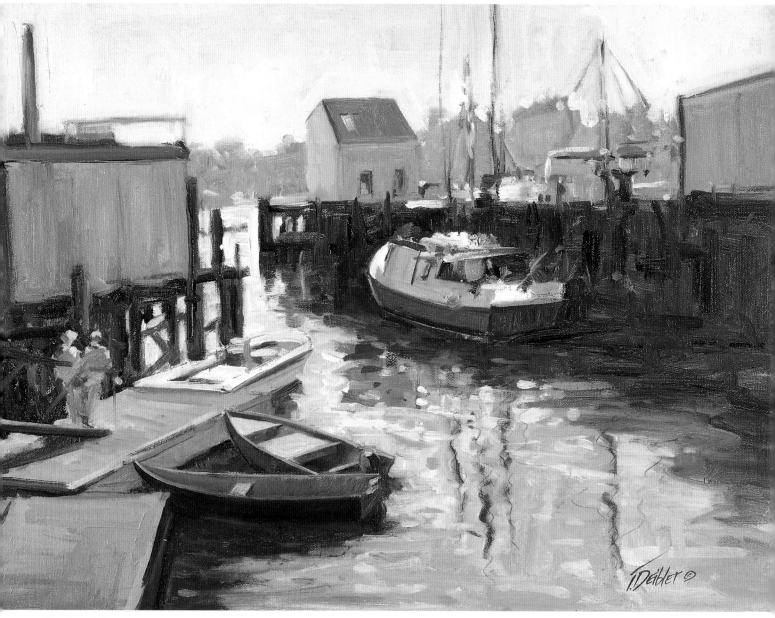

Dominant Oranges
Orange dominates this scene almost to the point of being monochromatic.
A touch of cool blue helps to keep the orange under control.

Plymouth Harbor I • *Oil on linen* • *12" x 16" (30cm x 41cm)*

Notice the incredible variety of interesting effects that can be obtained using this limited palette.

There are many challenges you face in doing a successful painting and one of the most important challenges is choosing your palette and being able to accurately mix the color you want. If you get to know your palette and what you can do with it, you can concentrate on other challenges.

DECISIONS, DECISIONS

I read recently in one of my old art books that we make about two thousand decisions in each painting!

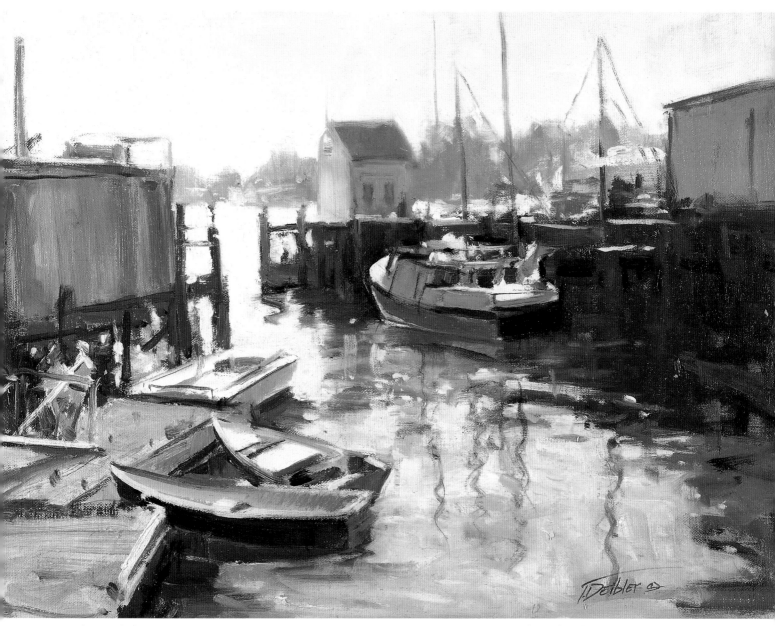

Dominant Blues
You can almost feel the moisture in the air because of the dominant use of blues. Cadmium Orange was mixed with Ultramarine Blue to darken and to gray it. The bright strokes of pure orange really bring this piece to life and keep it from getting too cold.

Plymouth Harbor II • *Oil on linen* • *12" x 16"* *(30cm x 41cm)*

Key Element IV: Edges

We now come to our fourth key element, edges. As mentioned earlier, all of these elements flow in and out of each other, working together to make a final statement to the viewer. Edges occur with every brushstroke on the canvas. They range from very distinct and sharp (hard edges) to very diffused (soft edges).

Edges are indispensable for leading the viewer's eye through a painting (be sure to reserve your hardest edges for your focal area). Edges are also essential for establishing depth and atmosphere. Soft edges can make objects appear to be far away while hard edges will make objects appear to be closer. Edges are also very useful for portraying the physical properties of objects. A rounded object will have softer edges, whereas a more angular object will have sharper edges. Edges in conjunction with the other key elements play an important role in expressing to the viewer the excitement you felt about your subject.

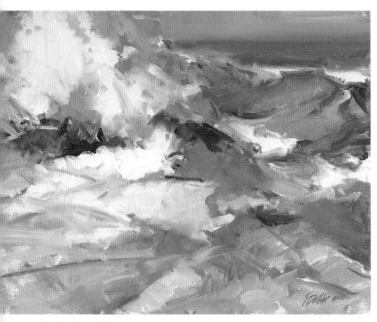

Capturing Edges

When you paint something that is constantly moving, like the ocean, it frees you from being too rigid with your shapes and brushwork. As I stood on the Oregon coast trying to paint the ocean with hard edges all I created was a static, lifeless painting.

As I observed the waves moving in and out and the water swelling and swirling and splashing all around, all I had heard and read about the use of edges began making sense to me. Edges create the transition zones into other areas of the painting so the viewer can be led through the piece without even being aware of it.

Pacific Surf · *Oil on canvas* · *12" x 16" (30cm x 41cm)*

Contrast Edges Within a Painting

By using softer edges in the clouds, you convey the softness, roundness and movement of the form. Using edges and brushstrokes that are firmer and more definite in the mountains helps to portray their ruggedness.

Clouds at Twin Lakes · *Oil on Masonite* · *12" x 16" (30cm x 41cm)*

Analyzing Edges

Let's take a close look at the variety of edges available for our use. Although this is only a small painting, there are a tremendous number of differing edges at work.

Edges at Work

Notice the soft edges at work in the bushes along the river. The edges of the bush on the left are lost into the hill. Not only is the edge soft, but the values are the same, making a smooth transition for the eye to follow.

The edges of the shadow on the distant hill are more defined due to the angularity of the mountain. The snow on the riverbank is painted with thick strokes of white creating a sharp distinction from the softer, rounded forms of the bushes. A dark accent under the snow emphasizes even more the hard edges of the bank, helping to establish the overall depth of the scene.

Winter Colors · *Oil on linen* · *5" x 7" (13cm x 18cm)*

Techniques for Creating Edges

By varying the methods you use to apply paint you can create interesting and different edge effects. The following examples demonstrate some of the edges you can create using a brush, a painting knife, even fingers.

Experiment with different types of brushes, rags, sponges or palette knives and see what effects you can create. Actually pushing paint around on the canvas itself will be your best teacher.

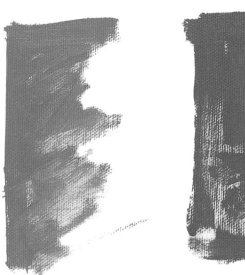

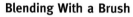

Using a Brush

You can use a no. 6 flat bristle brush to make a hard edge or a soft edge. To make the hard edge, use plenty of paint on the brush, then pull the flat side of the brush straight down. The soft edge is made with a scrubbing motion as you pull the brush from top to bottom.

Blending With a Brush

Using the same brush, merge the edges of two colors that are close in value together to make a soft edge. The more you blend an edge, the more the colors lose their individual identity and the paint surface will take on a slick overworked look.

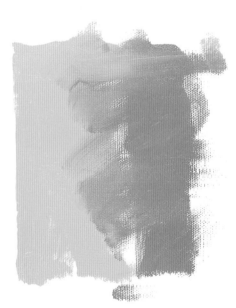

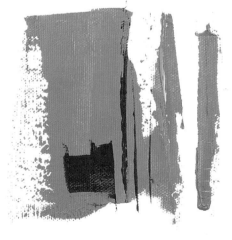

Using a Brush and Fingers

The yellow and the orange were both laid down with a brush, then the area where the two colors met was lightly blended with my fingers. (You might consider using gloves for this one!)

Using a Painting Knife

These bold strokes were laid down with a painting knife. Using the width of the blade you can cover a lot of area. By using the edge, you can create almost any thickness of line you want, from razor thin to a medium thickness.

Blending With a Knife

The result of blending these two colors with a painting knife is very similar to blending with your fingers. (And a little bit healthier too!)

Creating Atmosphere With Edges

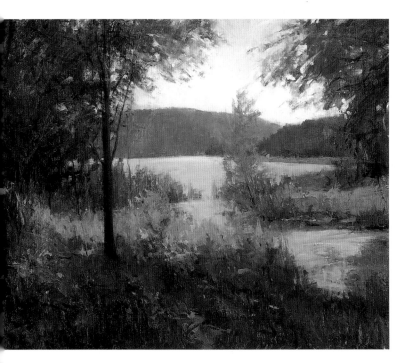

Soft Edges in a Painting

The soft edges throughout this painting help create a peaceful feeling. As the shapes melt in and out of each other, a few hard edges help to guide the viewer's eye along.

To keep the green from becoming too intense, I started this piece with a thin red wash. The red is particularly noticeable in the darker masses of trees on each side.

Atmospheric perspective is also at work here. Not only do things get smaller the farther away they are, they also get cooler in color and lighter in value. Yellow (the warmest color) is the first of the three primaries to drop out over distance, therefore the trees on the far hill take on a more reddish-blue look. If the distance were great enough for red (the next warm color) to drop out, the trees would look blue.

Quiet Summer • *Oil on linen* • *24" x 30" (61cm x 76cm)*

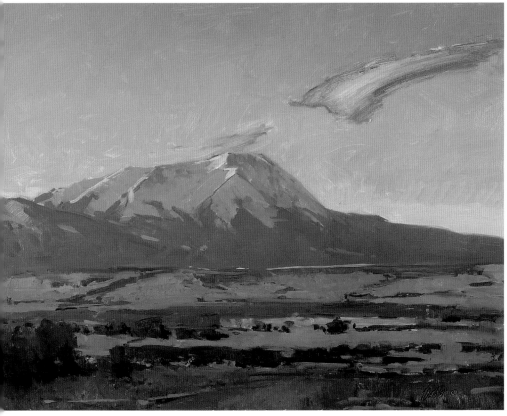

Painting With Hard Edges

The crisp, clear morning air and the strong form of the mountain call for painting hard edges. Only in the unusual-shaped clouds and the brush at the bottom left of the picture do we find softer edges. Did you happen to notice the complementary play of colors in this piece?

Early Morning Risers • *Oil on Masonite* • *18" x 24" (46cm x 61cm)*

Gallery

Shape

Look for the flow and rhythm of the shapes in nature. Establishing them simply as geometric forms will help you to quickly and accurately convey the truths of nature.

Summer Buildup • *Oil on linen* • *10" x 8" (25cm x 20cm)*

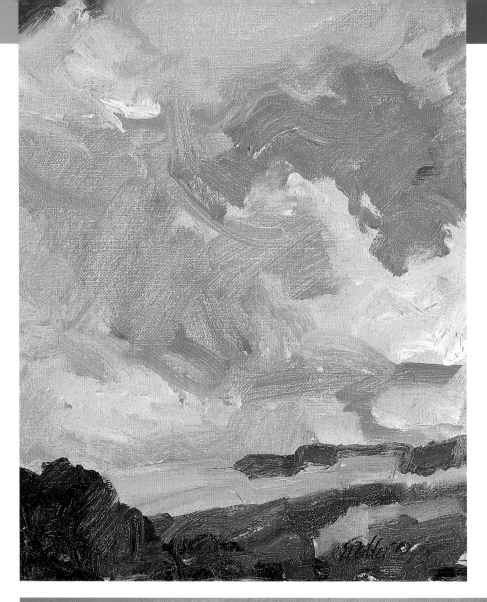

Value

Remember the importance of values in creating the mood or feeling of your work. Keep your value plan simple and let only one value dominate.

Between the Clouds • *Oil on Masonite* • *24" x 30" (61cm x 76cm)*

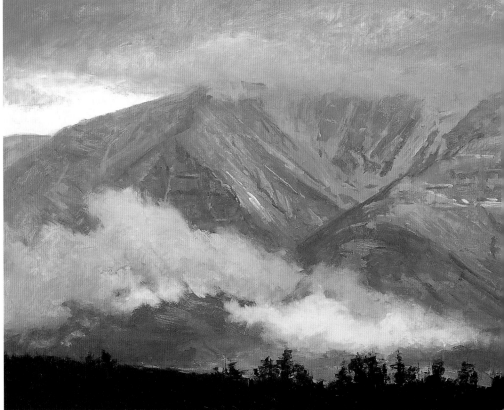

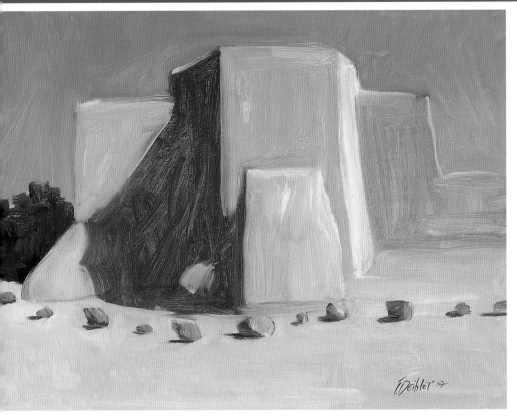

Color

With clear shapes and a simple value plan, the addition of color helps bring your personal vision to life. The sunny oranges of the building contrasted with the crisp blue sky set up an unbeatable complementary color combination for a perfect day in New Mexico.

Ranchos Church • *Oil on Masonite* • *9" x 12" (23cm x 30cm)*

Edges

Edges play an important part in guiding the viewer's eye through the painting. Softer edges allow the eye to pass from shape to shape while looking for something more definite to grab on to. Keep the hardest, most distinct edges around the main focal area and you won't go wrong.

Evening Light • *Oil on linen* • *8" x 10" (20cm x 25cm)*

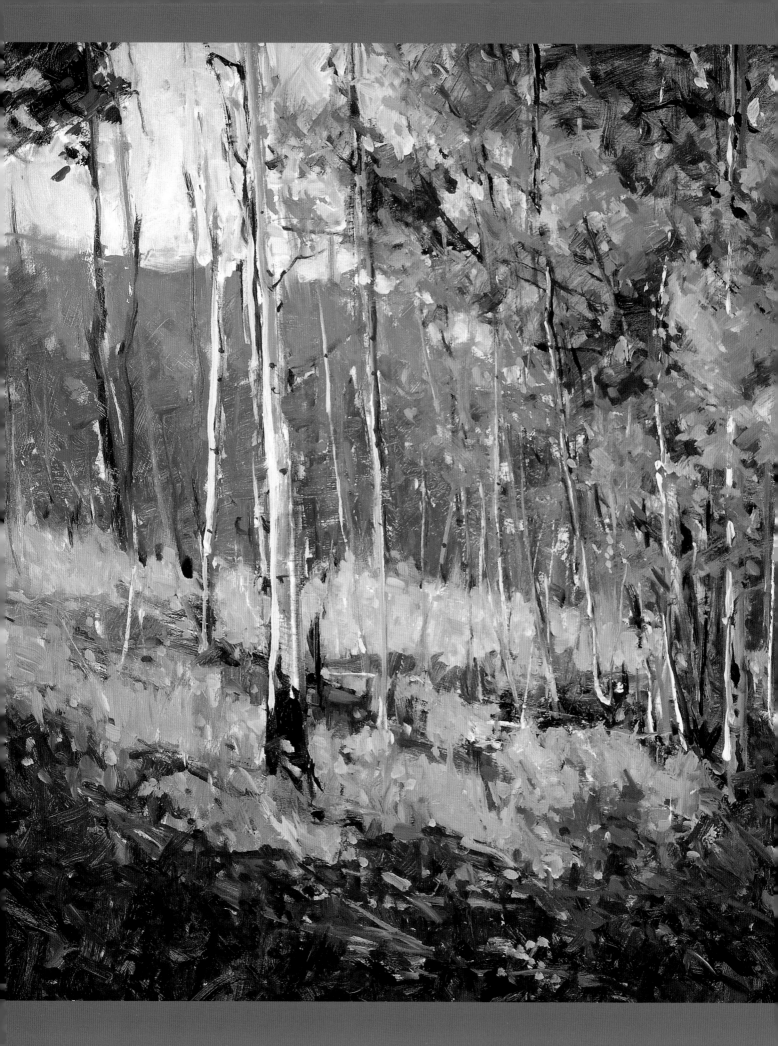

PAINTING METHODS

Now that you have a solid understanding of the key elements of a successful painting, the next decision you will need to make is how to get the scene onto the canvas. There are many different ways to start a painting, which can often be confusing for beginning artists. I often hear the statement, "I don't know where (or how) to start."

In this section we will take a look at five ways that I begin a new painting and why I choose each particular method. These methods are applicable to any style of painting from impressionistic to photo-realistic, so get your paints ready and follow along!

Summer Leaves • Oil on Masonite • 24" x 30" (61cm x 76cm)

Monochrome Block-In

■ As mentioned in the last chapter, monochromatic is using the values of one color (or a dark mixture of a couple of colors to create one color) to create a painting. This is a good way to establish a strong design whether the entire range of value is utilized or not.

Without color to worry about, you work directly with value, thereby setting the mood and dimensionality of your piece right from the start. Remember what we said about value on page 18. "Value is the most important element we have to convey the truth of nature."

Any color, or combination of colors that mix to create a single dark color, will work. I used Cadmium Orange and Ultramarine Blue to start this demonstration. Try Ultramarine Blue and Naphthol Red Light or Phthalo Blue and either red or orange. Burnt Sienna, a warm dark orange-brown, also works great for this technique.

MATERIALS

9" x 12" (23cm x 30cm) Canvas panel

PAINTS
Phthalo Blue
Cadmium Yellow Light
Cadmium Orange
Naphthol Red Light
Ultramarine Blue
Titanium White

BRUSHES
Nos. 2 and 6 bristle flats

OTHER SUPPLIES
Paint thinner
Paper towels

Reference photo

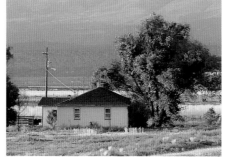

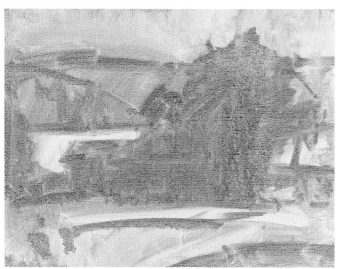

1 Establish the Value Pattern
Using your no. 6 flat and a thinned (with paint thinner) dark mixture, place your light- to mid-value shapes. Then with a darker mixture of Cadmium Orange and Ultramarine Blue, put in your darker shapes. Remember to think in terms of values and shapes, not individual objects. If three or four objects are near each other and equal in value, treat them as one shape (also referred to as "massing the shapes together"). Use a paper towel to wipe out any of the light areas that may have become lost while painting in the darker shapes.

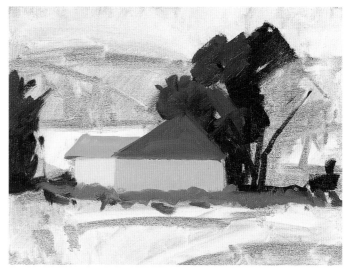

2 Define the Center of Interest
Start with your center of interest and define the most important shapes. Be as accurate as you can and remember to think in terms of simple geometric shapes. The house is a simple light blue rectangle of Ultramarine Blue and white, with a small touch of orange and red. The roof is a slightly distorted triangle made with the same colors using less white. Start with the main area of interest and get the most important characteristics down first so if the weather or light changes you've got the necessary information to finish the piece later.

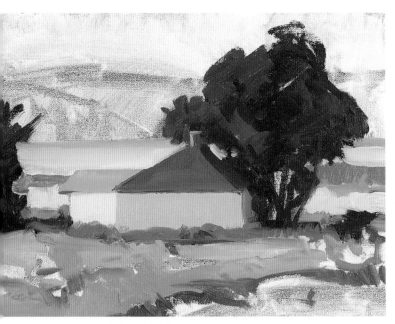

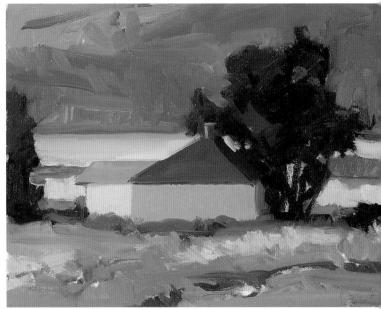

3 Paint the Light Areas

Finish filling in the shape of the tree with a dark green made of Phthalo Blue, orange and differing amounts of yellow. Work out from the house into the lighter grassy areas with lighter greens using lots of white and varying mixtures of Phthalo Blue, yellow, orange and Ultramarine Blue. This starts to create the feel of sunlight and helps to set the shadowed house into the picture plane.

4 Cover the Canvas

Now it's time to get the remaining untouched canvas covered so you can see the full impact of your image. Paint the earth colors in the front with mixtures of yellow, red, orange and white grayed slightly with touches of Ultramarine Blue. A touch of orange added to Ultramarine Blue and white will help keep the background in the distance.

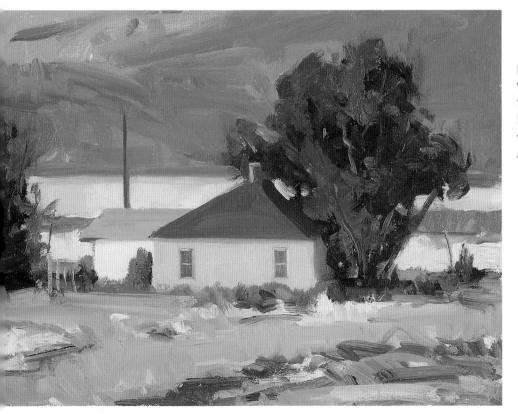

5 Final Details

Place your final details using a no. 2 flat. How many details does the picture need? That, of course, is up to you. I added the telephone pole behind the house, the windows and a few branches in the tree. Depending upon your personal style, now is the time to add all the trimmings!

Complementary Color Block-In

■ Winter and summer subjects can offer many challenges, one of them being an over-abundance of the same color. Large areas of cool colors need to be offset with something warm, and large areas of warm colors need something cool.

Many artists find summer subjects difficult because of all the greens. The complementary color block-in approach is a perfect solution for this kind of situation. By using thin washes of the complementary color (or any contrasting warm-cool relationship) that will show through in areas, you break up the monotony that can happen by too much of the same thing. Follow along with this demo as we use a red underpainting to paint a lot of summer greens.

MATERIALS

9" x 12" (23cm x 30cm) Canvas panel

PAINTS
Phthalo Blue
Cadmium Yellow Light
Cadmium Orange
Naphthol Red Light
Ultramarine Blue
Titanium White

BRUSHES
Nos. 2 and 6 bristle flats

OTHER SUPPLIES
Paint thinner
Paper towels

Reference photo

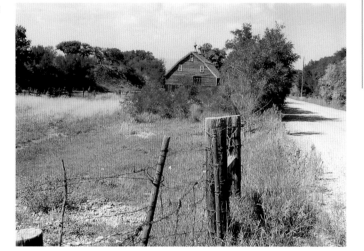

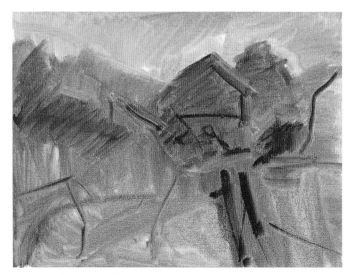

1 Using Opposites
Using your no. 6 flat, thin a small puddle of Naphthol Red Light and paint the entire ground plane, leaving only the sky blank. The sky will be painted blue when finished, so apply a thin wash of its complement, orange.

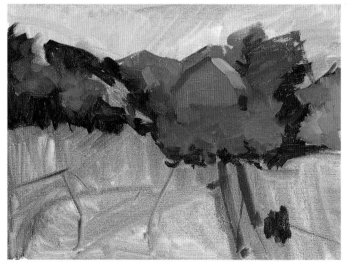

2 Paint the Barn
Carefully paint the shape of the weathered barn with Ultramarine Blue and red lightened with white. If the red barn color is too bright, add a touch of orange to gray it down. Mix a dark green using Ultramarine Blue with yellow and a slight touch of red. Carefully paint around the barn correcting its shape as you paint the trees. Add touches of yellow and orange to give variety to the trees as you work toward either edge of the canvas.

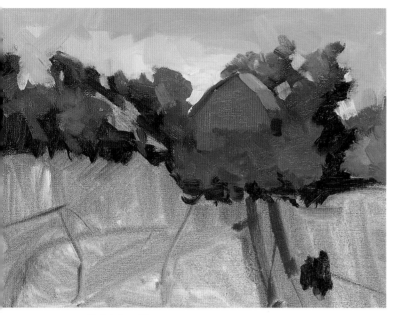

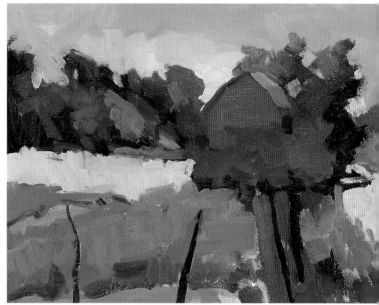

3 Paint the Sky

With a light mixture of Phthalo Blue and white, start painting the sky around the tree shapes and barn. Add more Phthalo Blue and a touch of Ultramarine Blue as you near the top of the canvas. In most cases the sky is lightest at the horizon and darkens as it moves up to the zenith (the area of sky directly overhead).

4 Add to the Foreground

Working from back to front, fill in the different colored grassy areas as distinct shapes. Use mostly Phthalo Blue and yellow for the various greens in the foreground. Also mix up a light tan color with orange, yellow, Ultramarine Blue and white and paint the dirt road on the right. The dark fence posts are suggested with mixtures of Ultramarine Blue, orange and red.

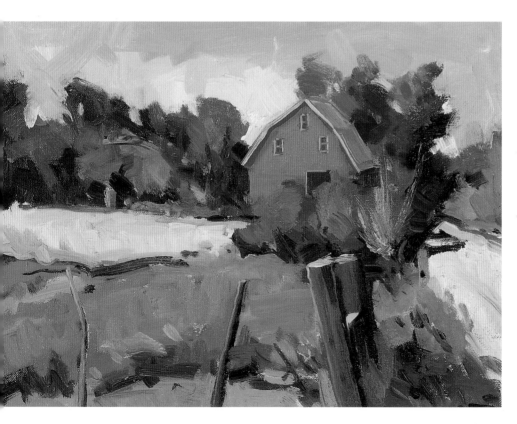

5 Final Details

The entire canvas is now covered and all the elements of the painting should be clearly defined. With your no. 2 flat, add windows to the barn and reshape any edges of the trees or grass that may have become lost or confused. Add a stroke of light cool gray made from Ultramarine Blue and orange on the left sides of the fence posts to give them form. Add your final highlights and dark accents to finish the painting.

Full-Color Block-In

■ By starting with the colors you want to finish with, you get a feel for the overall look of the painting from the very beginning. Oftentimes all it takes is a few strokes of thicker paint to bring your concept to life on the canvas. By leaving part of the original wash showing through, you create a vitality and sparkle to your work that you can't get any other way.

MATERIALS
9" x 12" (23cm x 30cm) Canvas panel

PAINTS
Phthalo Blue
Cadmium Yellow Light
Cadmium Orange
Naphthol Red Light
Ultramarine Blue
Titanium White

BRUSHES
Nos. 2 and 6 bristle flats

OTHER SUPPLIES
Paint thinner
Paper towels

Reference photo

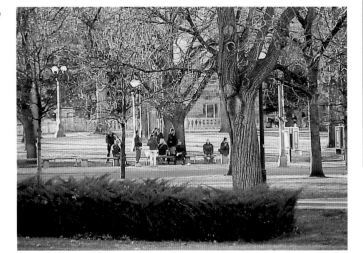

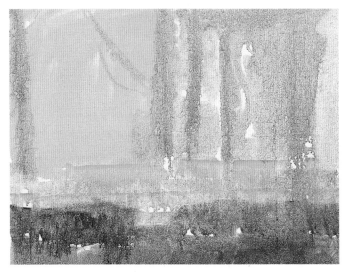

1 Start With a Thin Layer
Starting with your no. 6 flat, mix the colors for your subject and apply them very thinly in the approximate place your subject will go. Use a thin wash of Cadmium Yellow Light to indicate the square shape on the left and a thin mixture of Ultramarine Blue and Naphthol Red Light to indicate the larger purple square on the right. To indicate the bottom rectangle use Ultramarine Blue with orange and some yellow. Make your shapes and composition interesting early on while it's still easy to move things around. Keep your shapes bold and simple.

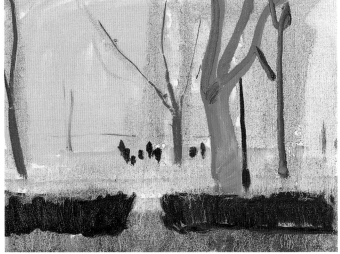

2 Establish Values
Carefully place the key features with a bit thicker paint. Use a mix of Ultramarine Blue, red and white to indicate the general placement of the main trees and a dark mix of Ultramarine Blue, orange and yellow to paint in the dark mass of bushes. Strongly define your values. The strength of your design should now be apparent. If something looks off, wipe it out with a paper towel and restate it.

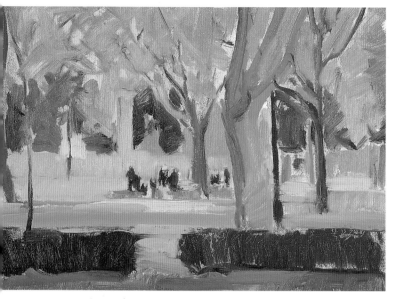

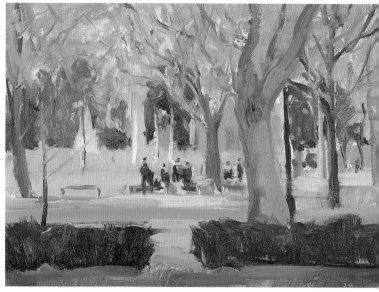

Cover the Canvas

3 Work all over the canvas, going from your light to middle to dark values. For the foliage use mixes of red and Ultramarine Blue, for the background trees use Phthalo Blue with orange and yellow, and for the foreground grass use yellow and Ultramarine Blue. Adjust the value by mixing white with the different mixtures. Clearly define your shapes, working from large to small. Keep the spaces between objects interesting by making them different sizes. Be sure to leave areas of the original wash showing through; this will add sparkle to the finished painting.

Start Adding Details

4 Start honing in on the center of interest (the group of people) and work out from it. Carefully, with your no. 2 flat, suggest some of the characteristics of the group such as a backpack and a red shopping bag. Use a dark stroke made from Ultramarine Blue and orange for their heads, refine larger shapes into smaller, more accurate shapes. Add a variety of color and detail into the tree trunks, and intensify the effect of light with short strokes of yellow mixed with white in the foliage. Work over the entire painting so that it comes into focus as if you were looking through a camera lens.

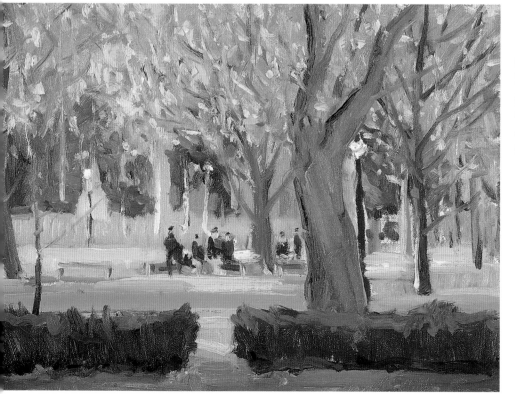

Make Final Adjustments

5 Look over your subject carefully, then look over your painting. Find the places you can add dark accents or a bright highlight. Indicate the street lamp globes and check your edges. Do some need to be softened or restated for emphasis? Only add the touches that will make your final statement stronger.

Light and Shadow Block-In

■ Many times in landscape painting you will see the clear division of light and shadow in large simple shapes. Evening light is particularly good for this effect. As the sun lowers, the shadows rise on the landscape leaving only the highest objects illuminated by the golden light. Capturing the division of shape between light and shadow quickly is the advantage of the light and shadow block-in approach.

MATERIALS

9" x 12" (23cm x 30cm) Canvas panel

PAINTS
Phthalo Blue
Cadmium Yellow Light
Cadmium Orange
Naphthol Red Light
Ultramarine Blue
Titanium White

BRUSHES
Nos. 2 and 6 bristle flats

OTHER SUPPLIES
Paint thinner
Paper towels

Reference photo

1 Separate Light and Shadow
Using your no. 6 flat and thinned Cadmium Orange for the sunlit areas, quickly establish the area in direct light. Next, use thinned Ultramarine Blue to fill in all the area in shadow. It's important to see all the objects of the scene as either in light or shadow and not spend time on any individual objects.

2 Lightest Light and Darkest Dark
Look at the simple geometric shapes in your scene and establish the lightest light (a patch of snow) with white mixed with a touch of yellow. Using a mixture of orange and Ultramarine Blue, place the darkest darks (the fence and phone pole).

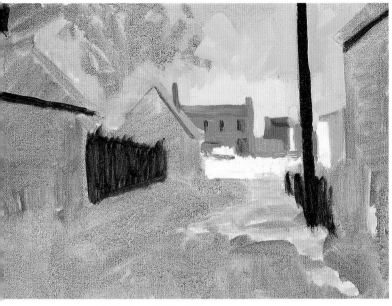

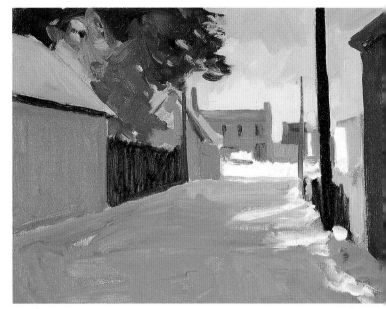

Establish Individual Shapes

3 Now start with your center of interest and establish the individual shapes of objects. In this case the center of interest is the red brick building in the distance. Start with your main interest and work out from it. Keep it simple by using a large, no. 6 flat; we're not talking about fine details.

Paint the Shadows

4 Now work into the areas of snow that are in shadow. Look for the big basic geometric shapes and start painting them. The snow in shadow is painted using Ultramarine Blue with touches of orange and red.

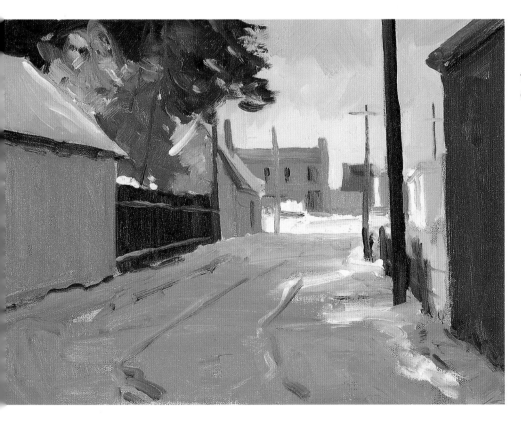

Add Final Details

5 Depending on your individual style and degree of finish, now is the time to use the smaller, no. 2 flat to add details.

Direct Painting

■ If the shortest distance between two points is a straight line, then direct painting would have to be the shortest distance to the final painting. This approach aims for the finish line from the very first stroke; nothing is wasted or covered up. When time is of the essence, this could be your best option. I once heard an artist say, "It doesn't matter how much you get down, as long as what you do is accurate."

MATERIALS

9" x 12" (23cm x 30cm) Gesso-primed Masonite panel

PAINTS
Phthalo Blue
Cadmium Yellow Light
Cadmium Orange
Naphthol Red Light
Ultramarine Blue
Titanium White

BRUSHES
Nos. 2 and 6 bristle flats

OTHER SUPPLIES
No. 2 pencil
Paper towels

Reference photo

1 Pencil Sketch
Quickly do a pencil sketch showing only the major directional shapes and placement of the main objects. Keep it simple. This sketch is just a guide to follow, not a rigid outline to fill in.

2 Start With Thick Paint
Fully load your no. 6 flat with your lightest light and jump in! Start with Cadmium Yellow Light and white to establish the lightest areas on the distant cliffs, then add orange and red to your mixture for other rocky areas. Don't be hesitant or timid; paint with authority. When painting from life, consider which areas, the light areas or the shadow areas, will change the most drastically because of the sun or cloud cover, then paint those areas first.

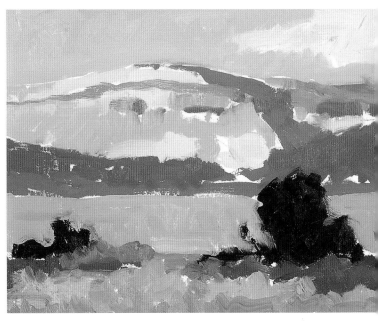

3 Paint the Darkest Area

Having simply established the light area pattern in step 2, direct your attention to the shadow areas on the cliffs and tree shapes in the foreground. Ultramarine Blue and white is used for the shadows on the cliffs. Add a touch of orange if you think the blue is too cold. Use Phthalo Blue and orange to make a rich dark value for the trees. This dark value in the front will push the cliffs way into the distance. At this point, the major light areas and major dark areas have been painted.

4 Add Middle Values

Mix up a warm ochre color using orange, Ultramarine Blue and yellow, lighten the mixture with white and paint in the middle ground. Lighten the mixture with more white and add a touch of orange to warm the color slightly and paint the remaining areas on the distant cliffs. The middle ground is cooler (with more blue in the mix) than the background because it is in shadow; the cliffs are receiving the warm sunlight. The sky is a mixture of Phthalo Blue and Ultramarine Blue, with a touch of red for the cloud on the right.

5 Refine the Edges

Still using your no. 6 flat, pay careful attention to the edges of your objects. Soften the area where the cliffs meet the sky. Add a touch of orange to the trees and firmly restate their shape. Use your no. 2 flat to put in any final highlights or accents.

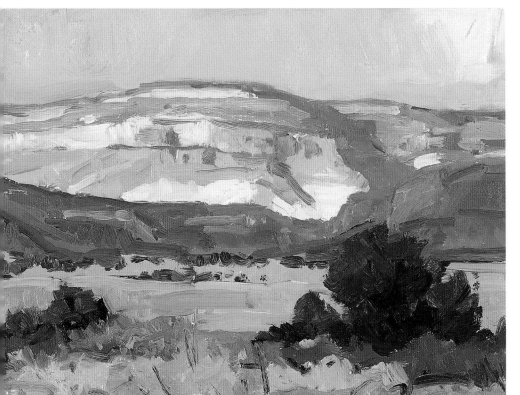

Summing Up

These short demos were designed to show you some of the many different approaches or techniques for starting a painting. There is no one right or wrong way in painting. I know artists that start with their darks and work to the lights. Other artists start with the middle values and then refine them with darker and lighter values. I even know artists that always start with the lightest light and work to the darks. Try different methods to see which process makes the most sense to you. The more knowledge and experience you have, the better decisions you will make.

Let's take a closer look at some of the common elements visible in these different painting methods.

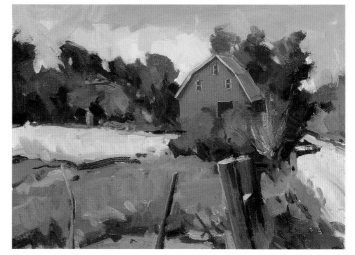

The underpainting was left exposed in areas.

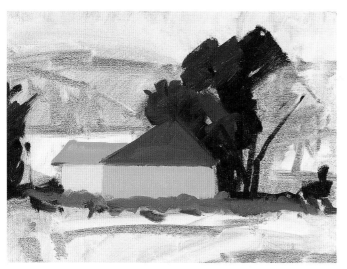

In each method the objects were treated as simple geometric shapes.

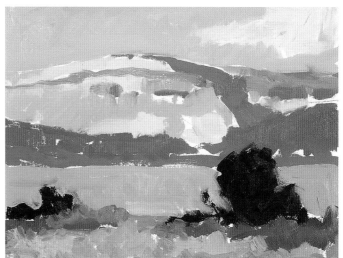

The entire canvas was worked on and brought to a conclusion as a whole.

Each painting was developed from the general to the specific, large shapes to smaller detailed shapes.

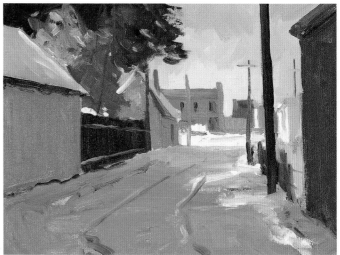

The fine details, accents and highlights were applied last.

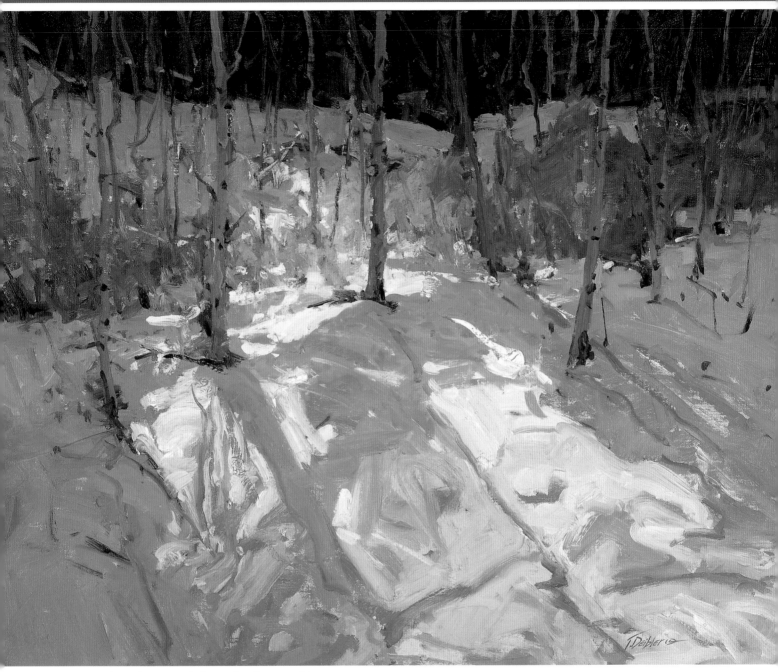

Use Brushstrokes to Reinforce the Center of Interest

This cold, snowy landscape is still filled with sunshine and warmth. Since the warm areas are the center of interest, they contain the most lively and interesting brushwork. A few dark accents define the tree trunks, and the use of warm and cool blues keeps the snow from being too cold. This was painted in the full-color approach leaving lots of the original block-in showing through. Very little refining was necessary to finish the painting.

Winter Patterns · Oil on linen · 24" x 30" (61cm x 76cm)

Gallery

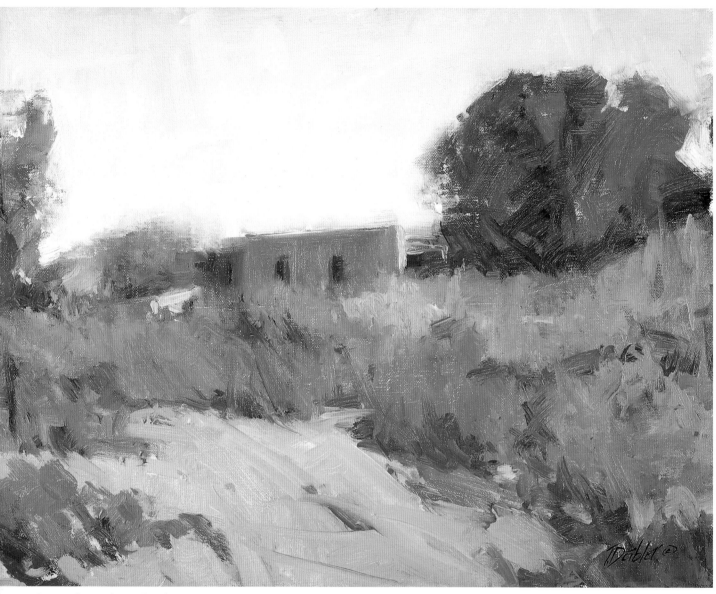

Atmosphere Through Edges

Soft edges prevail throughout this painting, creating the feeling of a warm, sunny day in New Mexico. The pale sky contains some of the ground color, and the ground contains some of the sky color. A variety of greens present in the bushes and trees move your eye throughout the painting. Once again it's the mood that is important, not factual details.

Taos Adobe • *Oil on linen* • *12" x 16" (30cm x 41cm)*

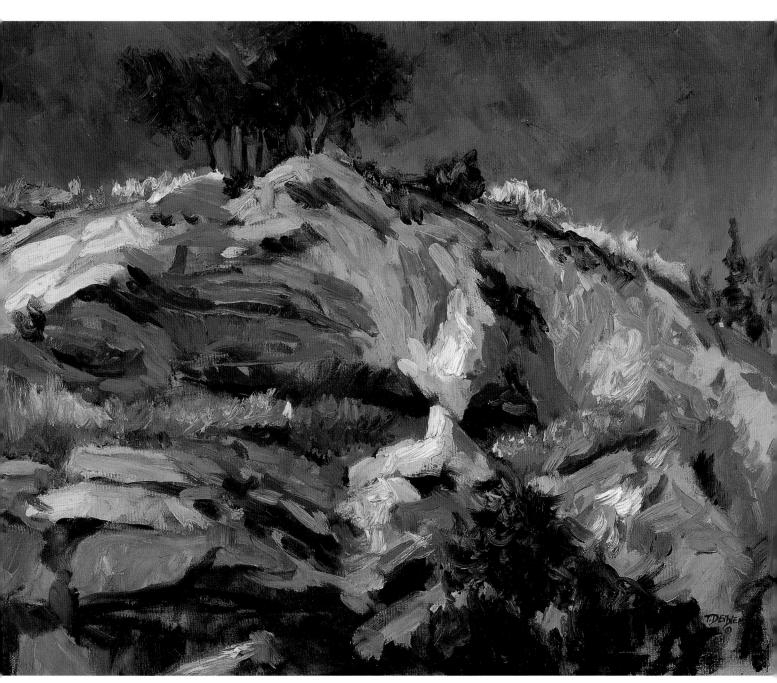

Strong Contrasts

Strong values, expressive brushwork and a complementary color scheme make this painting of Golgotha visually exciting. The dark, brooding sky sets the stage for the strong light on the rock face. This was painted soon after returning from a trip to the Holy Land while the memories and emotions of the visit were still strong.

Matthew 27:33 • *Oil on canvas* • *16" x 20" (41cm x 51cm)*

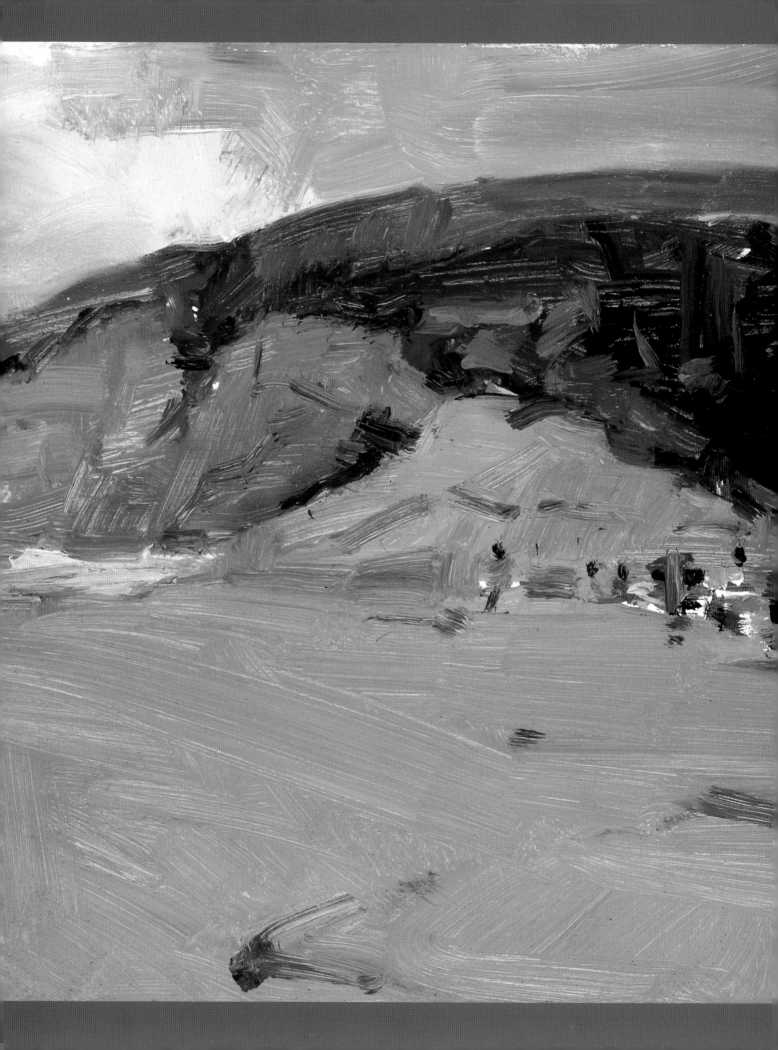

3

NEITHER RAIN, NOR SNOW, NOR HEAT, NOR HUMIDITY

Packing up your easel and heading for the great outdoors can be a rewarding experience. As artists, we are likely to appreciate the wonders of nature and find a suitable subject in even the most common places. However, working outside presents an entirely new set of obstacles to overcome. We have to deal with the technical aspects of a good painting while nature overloads us with a myriad of subjects and details to sort through—not to mention the artist's greatest challenge, the often harsh and ever-changing weather conditions.

Beach Party · Oil on Masonite · 6" x 9" (15cm x 23cm)

Plein Air Equipment

The excitement and satisfaction of painting is in the process, not just in the finished piece. Spending a day in the field, confronting nature head-on with brush and canvas, is possibly the biggest reward you will ever receive for your hard work and dedication.

You can't pack up your entire studio and stuff it in your car every time you go outside; therefore, you need portable equipment that is simple, durable and sufficient in order to accomplish your artistic goals. Along with the miscellaneous supplies mentioned, I have found the following equipment to be invaluable.

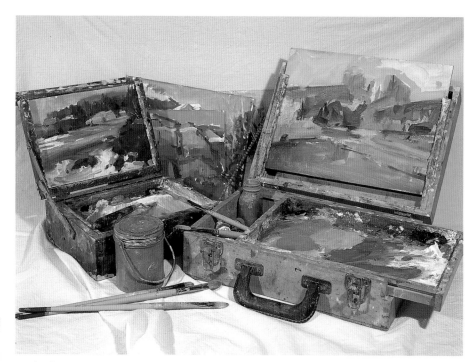

BRUSH STYLES

There are four basic styles of bristle brushes generally used for oil painting. They are filberts, flats, brights and rounds. My favorite is the flat; it comes to a square tip and its long, flexible bristles can carry a lot of paint and give a very precise thin or thick stroke. A filbert is a flat brush with a rounded tip and leaves a softer stroke. A bright is squared like the flat but the bristles are not as long, making it a stiffer brush to use. The round brush has long bristles and comes to a point like many watercolor sable brushes.

Pochade Boxes

I use a variety of small, handmade (by friends) Pochade boxes. Equipped with a tripod mount, they can be attached to a camera tripod and ready for action in a matter of seconds. They are great for use in a vehicle when the weather is unsuitable outside, or they can be stuffed into a backpack when walking distance is too far to make carrying a larger easel practical.

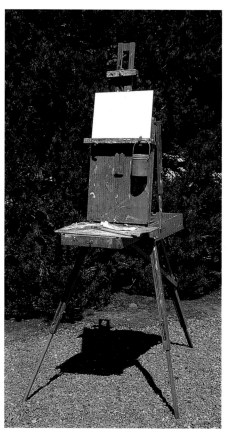

Easels

With the increased interest in plein air painting, easel manufacturers have kept up with demand by offering an incredible variety of portable easels. My favorite is the standard French easel made by Jullian. I have used mine for over twenty years and only recently had to replace a leg that broke on a painting trip. When painting in windy conditions, be sure to place a rock or other heavy object in the easel to keep it from blowing over.

Value Finder

Painting the correct values outside is one of the most challenging things about plein air painting. More often than not things are painted too dark. A simple way to keep from painting too dark is to include an inexpensive roll of black electrical tape in your paint box. When viewing your scene, stretch out the tape and hold it up in front of you at arms length. Compare the black tape with the values in the landscape and locate the darkest dark. While your painting is in progress you can check the value relationships by holding the tape in front of your painting and then comparing it to the scene.

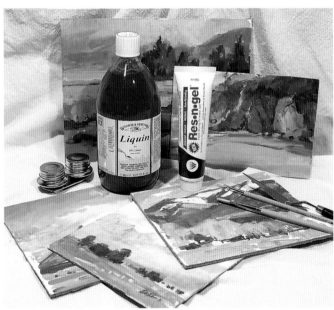

Miscellaneous Supplies

Of course, good judgment should be used on any painting outing. Make sure you have plenty of water to drink, a hat, bug spray, sunscreen, suitable clothing for the weather, camera, sketchbook, plastic bags for garbage, an extra roll of paper towels and an extra container of paint thinner. One time I went painting with a friend and had everything, except my paint.

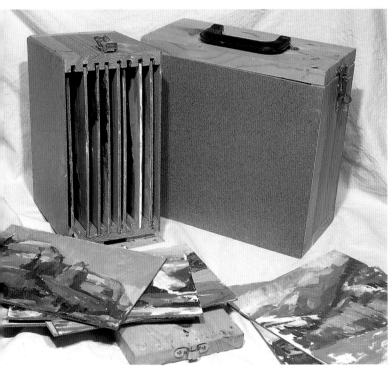

Panel Boxes

Transporting wet paintings presents a huge problem for artists. There's always the chance that we will drop the finished masterpiece face down before we get it into the car or back home to the studio. Many art suppliers are carrying special boxes made with grooves inside to slide the wet paintings into. However, the box can be easily made with just a few basic woodworking tools.

Mediums

Using quick-drying mediums to speed up drying time is a tremendous help on painting trips. There are many available today from different manufacturers, but the two I use the most are Liquin made by Winsor & Newton, and Res-n-gel made by Weber. Both are an alkyd-based medium which helps oil paint dry faster. Liquin has a thick syrupy consistency and is great for thinning oils and glazing while Res-n-gel has a buttery consistency great for retaining thicker brushwork.

I'm Outside, Now What?

On any great information-gathering quest, particularly when accumulating reference material for painting landscapes, you will soon discover the biggest handicap of all—your inability to control nature. Unlike still life or figurative painting, nature calls the shots on the lighting and location of your potential landscape subject. Aside from the usual bugs, curious onlookers and the blowing wind, you have to take what nature dishes out and bend it to your will and purpose. How many times do you find the river in the wrong spot, the trees too tall, or too much or too little snow? Or, while you are painting, your subject suddenly disappears behind the clouds that weren't even there when you started.

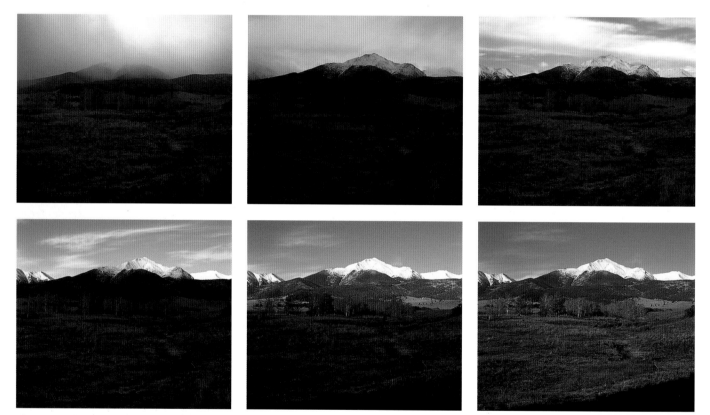

The Ever-changing Weather

This series of six photos was shot one morning when a good friend, Dix Baines, and I got up early to catch the sunrise on the Sangre de Cristo mountains in Colorado. When we arrived, our potential subject wasn't even visible. The important thing I want you to note in this series of photos is that they were all shot consecutively in less than one hour—from an early morning rain/snow combination to full sunlight. It's important to be able to decide quickly what you want to say in a painting, then stick to that idea even though the scene may change before your very eyes.

Choosing the Best View

The three-dimensionality of our world has always fascinated me. When visiting museums and galleries I enjoy walking all around the sculptures, viewing them from every angle. When I was in Italy as an art student I photographed Michelangelo's famous statue of David from the back because every picture I had seen in art books was always from the front. I find the way things change as you move around them can spark a whole new vision for a painting. Since you are painting on a two-dimensional canvas, simply changing your vantage point can sometimes transform an ordinary subject into a pictorial masterpiece.

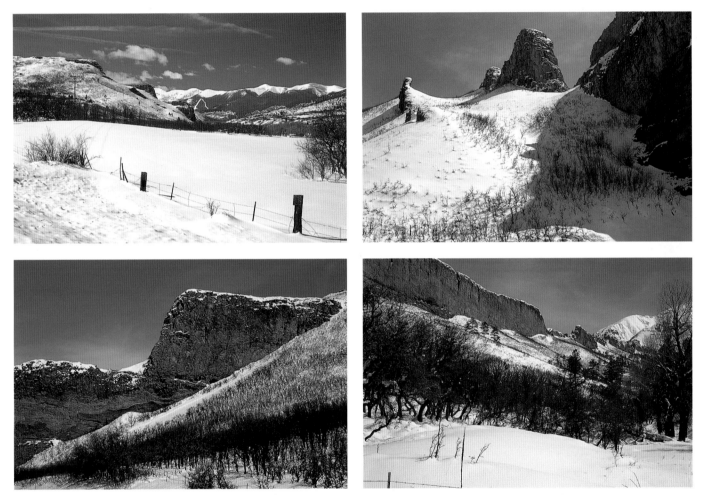

A Multitude of Possibilities
A local landmark, this volcanic rock formation near my home is referred to by many as the Devil's Stairsteps. Formed by molten rock that pushed its way into vertical fractures in the sedimentary strata, these volcanic dikes radiate out from the Spanish Peaks mountains like the spokes of a wheel. The dikes form huge walls protruding up from the eroding soil measuring up to one hundred feet wide, the longest one stretching for fourteen miles. It's fascinating to see the different pictorial possibilities of this dike wall simply by changing your viewpoint. Add to this the constantly changing light and seasonal weather conditions, and you have an endless supply of reference material.

Making the Most of Field Work

Most of us would agree that there is never enough time to do all we need to do. So when we finally make it out of the studio and into the field, we feel rushed because there is so much to see and paint, and so little time.

Once in awhile, however, you may find that just the opposite happens. While looking for the perfect scene to present itself, you search all day waiting for inspiration to strike and then go home empty-handed.

Next time you venture to the great outdoors, try some of these tips to help you make the most of your time.

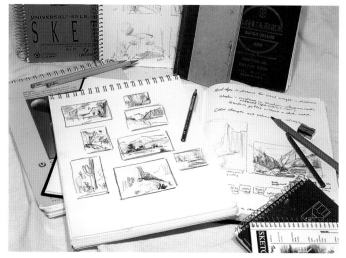

Tip 1–Pencil Sketching
For getting a visual thought down quickly, pencil sketching is the most accessible and economical of all media. Grab a pencil and paper, even a napkin, and draw! Draw! Draw!

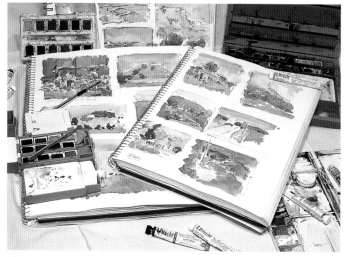

Tip 2–Use Watercolor
Watercolor is a great portable medium for recording an image quickly on the go. These color sketches were done while I was riding in a car as a passenger during a family vacation. It's a great way to paint while traveling in a vehicle, as long as you're not the driver.

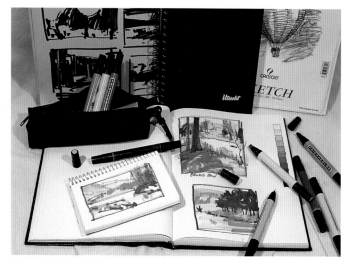

Tip 3–Use Markers to Note Values
Remember the importance of values? Establish them quickly with marker sketches. Available in different percentages of gray, markers are terrific for doing thumbnail composition studies.

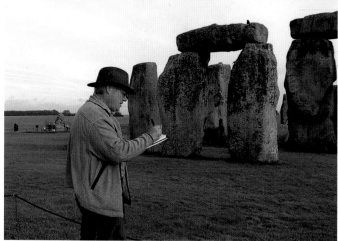

Sketching Stonehenge
A quick sketch with gray markers and a series of photos are perfect when it's not convenient to work with oils (such as a bus tour of Stonehenge). See page 97 for the finished painting of Stonehenge.

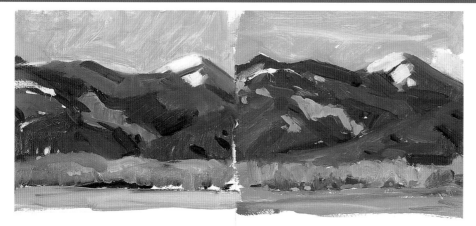

Tip 4–Work on a Series

Explore a fascinating scene by doing a series of studies of the same subject on one panel. Simply divide the panel so you have two smaller areas at the top and one large area at the bottom. Start with a quick ten-minute black-and-white value sketch in the top left area of the panel. Keep it simple. In the space at the top right, do another ten-minute value sketch, only this time in full color. Now that you have a solid vision of the value, color and composition of your subject, you are ready to do a more finished piece at the bottom of the panel. I painted this series of Taos Mountain in Taos, New Mexico, just before sunset. Colors change quickly in the evening as the sun goes down, and before I could even start on the finished work, the sun had bathed everything in a magical light. The value pattern, however, remained fairly consistent.

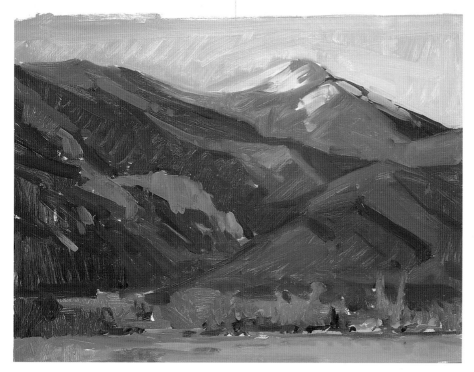

Tip 5–Take Photographs

When it comes to recording fleeting light effects and intricate details, photos are indispensable. Digital cameras make it easy to photograph your subject and to print a picture from your computer as soon as you get back to the studio (before you lose your inspiration). Take advantage of all the electronic tools available. Video cameras can be tremendously useful to capture the movement of clouds and shadows or to study ocean waves.

Choosing the Best Time of Day

After choosing your subject and exploring its many different angles, your next consideration should be the best time of day to paint it—when the light is at its best for the scene. What light best reveals the characteristics and qualities that you want to express about the scene? Certainly the early morning and late evening sunlight has a magical quality about it, but does that time of day enhance your subject? If you live near the scene you can make repeated trips to determine the best conditions. But if you are traveling, you may not have the luxury of choosing the best light and just have to paint the scene as it is.

Early Morning Sun
The pink light of dawn strikes only the east facing slopes of the East Spanish Peak in southern Colorado, leaving the north face in cool shadow. Colors change quickly; the pink lasts for only a few minutes

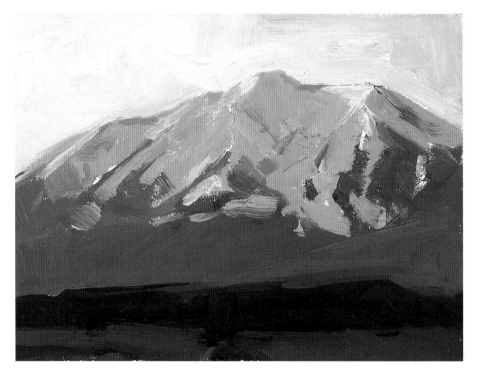

Mid-Morning Light
By mid-morning the sun has bathed more of the mountain in light, thus creating a more interesting shadow pattern and revealing more of the peak's form.

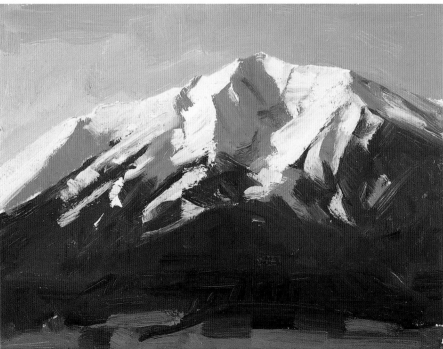

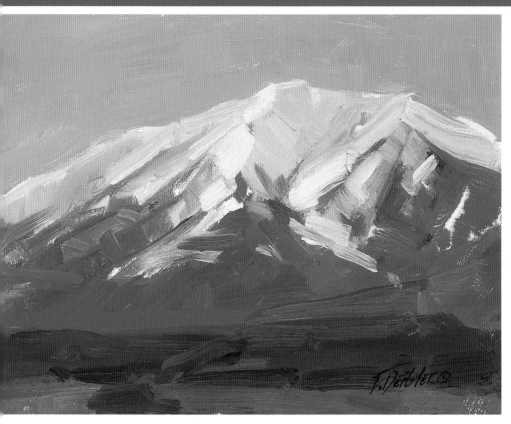

Noon Light

By noon the sun is overhead and the light has a flattening quality about it, only illuminating the very tops of objects. This would be the time of day to emphasize patterns and rhythms in nature rather than dimensional form.

THE IMPORTANCE OF LIGHT

The quality of light and the prevailing weather conditions certainly affect the sensation we receive from the landscape. Through light both form and feeling are revealed. It is this mixing of nature and our personal vision that we must use to create art.

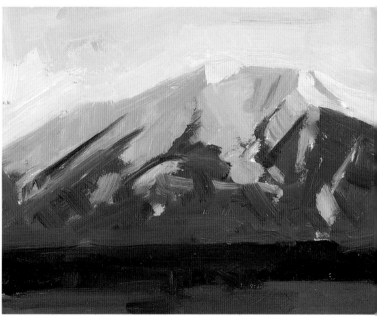

Afternoon Light

A complete shift between the light and shadow areas has occurred by the middle of the afternoon. What was in midmorning shadow is now in strong sunlight, revealing an entirely different aspect of the mountain's form.

The Setting Sun

The final golden rays of sunset move up the mountain slopes as the sun goes down. In just a few seconds all direct light will be gone, leaving the entire landscape illuminated only by the sky.

Plein Air Step by Step

■ Painting outside is one of the quickest ways to grow as an artist. It takes you out of your comfort zone and puts you face to face with your subject. Your skills of observation and speed are sharpened as you are forced to make decisions quickly.

When you go out to paint there are many choices you have to make before you pick up your brush, finding a suitable subject is just the beginning.

First of all, let me stress the importance of safety. A major consideration is finding a safe place to park your vehicle off the road and out of the way of traffic. Also, be careful where you place your easel; don't get too close to the edge of a cliff or other precarious place that could be hazardous to you or someone else. Consider property owners' rights; if you are painting on private property be sure to ask permission first.

MATERIALS

12" x 16" (30cm x 41cm) Canvas panel

PAINTS
Phthalo Blue
Cadmium Yellow Light
Cadmium Orange
Naphthol Red Light
Ultramarine Blue
Titanium White

BRUSHES
No. 6 bristle flat

OTHER SUPPLIES
Camera
Paint thinner
Paper towels
Res-n-gel medium

Reference Photograph

When you find the perfect view, I recommend that you immediately take several photographs of your subject. Identify what it is that caught your attention and made you want to paint the scene. Chances are the scene will undergo many changes during your painting session, so it's important to have a photographic record for reference later.

Set Up

Choose a safe place to set up your equipment. My easel is located on a private bridge crossing the stream. The land owner came out to watch so I didn't have to worry about blocking his road. For the sake of photographing this demo, I mounted my canvas panel with duct tape on a slightly larger board painted black.

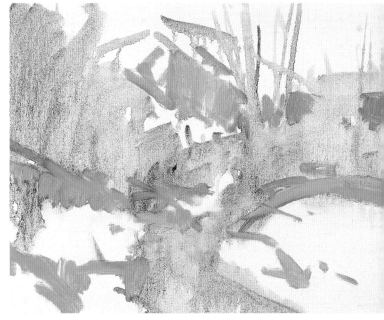

1 Establish Composition

Start by diluting a mixture of Cadmium Orange and Ultramarine Blue to a very thin consistency using paint thinner. Lightly block in the major dark shapes of the trees and river. Add more Ultramarine Blue to indicate the background mountain and a touch of red to the trees on the left side.

2 Add Shadows

The bright sun is creating very strong shadows. Establish these with a mixture of white, Ultramarine Blue and just a touch of red. Add Res-n-gel to your paint as you start using thicker paint (after the initial wash). Res-n-gel is the same consistency as your paint and will enable you to paint thickly and boldly with the added benefit of a quicker drying time. Keep your brushstrokes loose and spontaneous.

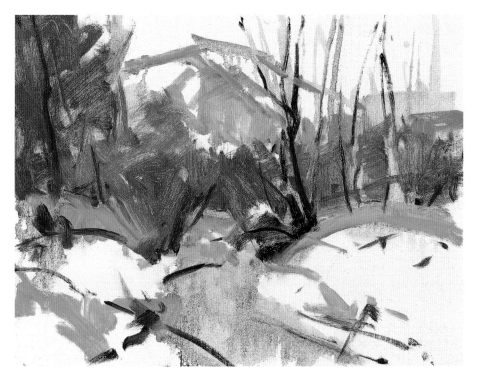

3 Define Shapes

Strengthen the color and values of the trees and bushes using a variety of mixtures of Ultramarine Blue, orange, red, yellow and white. With a dark mixture of Ultramarine Blue and orange, indicate the major tree trunks and the dark edges of the riverbank.

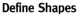

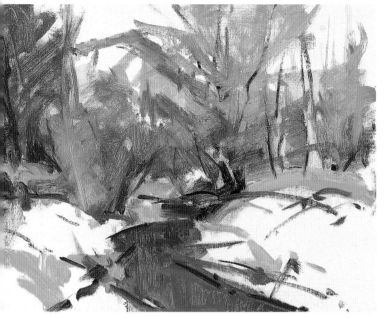

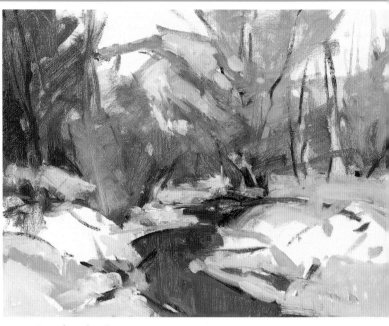

4 **Paint the River**
Using Ultramarine Blue and red, loosely paint the river in the background; then add warmth to the river foreground by using yellow and orange with a touch of Phthalo Blue. Further develop the tree in the center using broad strokes of cool gray made with Ultramarine Blue, orange and white. Use the same mixture, sparingly, on the ochre colored bush on the left and the distant trees on the right.

5 **Develop the Snow**
Paint in the cool areas of snow that are not receiving the warm direct light from the sun. Use mixes of Ultramarine Blue, Phthalo Blue and white. Add a touch of orange if the mixture needs to be grayed down a bit.

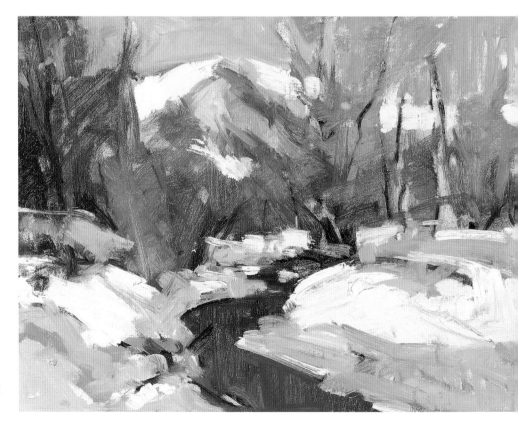

6 **Paint the Sky**
With a pale mixture of Phthalo Blue, white and a slight touch of red, reshape the mountain and trees as you paint the sky around them. Using white and a touch of yellow, thickly paint in the snow that is in bright sunlight.

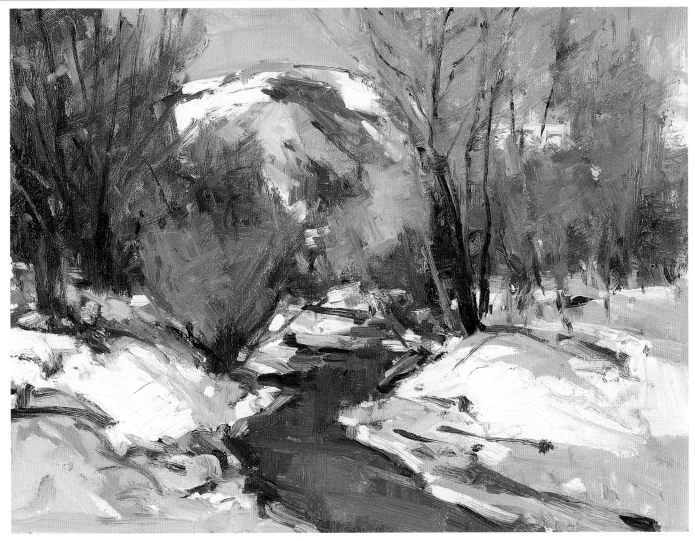

7 Step Back

Step back from your work and really look at your painting. Are the shapes clear? Is there a sense of depth? Are any areas confusing? Now is the time to soften edges and restate any necessary darks that were lost. Redefine the top of the mountain, restate some tree branches and correct the edge of the stream. Add as much detail as you want.

March Snow • *Oil on linen* • *12" x 16" (30cm x 41cm)*

Gallery

Warm Light With Cool Shadows

Late afternoon is certainly my favorite time of day to paint. As the sun lowers toward the horizon in Taos, New Mexico, the landscape is illuminated with a golden glow. Coupled with deep shadows and a stormy sky, I have the makings of a dynamic landscape.

Evening Light in Taos • *Oil on Masonite* • *8" x 10" (20cm x 25cm)*

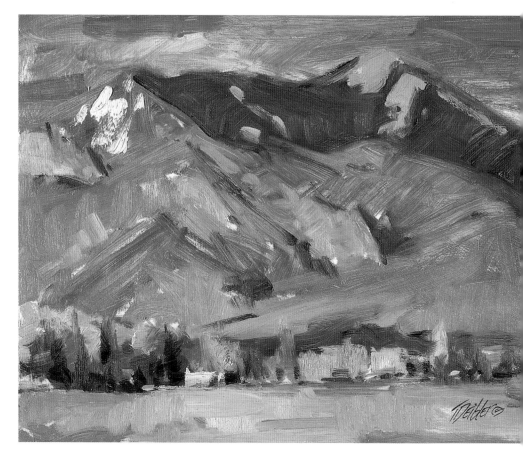

Bold and Simple

Although the color combinations are very similar to Evening Light in Taos, this sketch was actually painted in the middle of the day just before it started to rain. Because of the dark blue of the distant hill, the river and ochre-colored grasses stay located in the foreground.

Upper Huerfano River • *Oil on Masonite* • *6" x 8" (15cm x 20cm)*

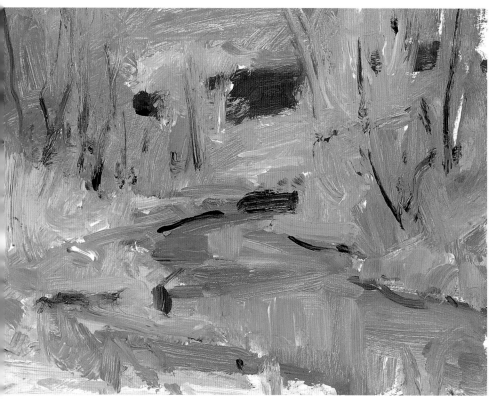

Just One More

After a full day of painting with my friend, Jane Ford, we were on our two-hour drive home when the mountains turned a beautiful pink. We couldn't resist, we pulled the car to the side of the road and quickly got to work. This was painted in about 20 minutes using my Pochade box attached to a tripod.

Alpenglow · Oil on Masonite · 8" x 12" (20cm x 30cm)

Exaggerate Color

Spring offers the outdoor artist some of the most beautiful colors of any season. As the trees bud and flowers start blooming, the landscape comes back to life. Working small and quickly allowed me to capture this special season.

Spring · Oil on Masonite · 5" x 9" (13cm x 23cm)

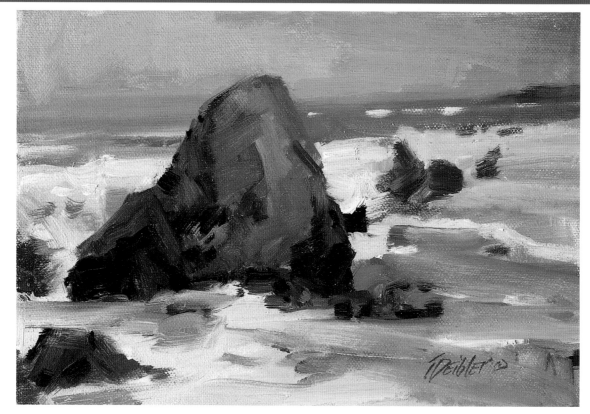

Vary the Amount of Detail

Rocks and water are a fascinating combination, whether it's a quiet mountain stream or the rugged rocks and pounding surf of the Pacific Coast. In this painting I've placed importance on the foreground rock using defined edges and value changes. The other rocks fade off into the distance because of their simplicity (soft edges and less intense color). The paint is relatively thin except for a few highlights in the water.

Coastal Rocks • *Oil on canvas* • *6" x 9" (15cm x 23cm)*

Expressive Brushwork

Painted in the afternoon, these rocks are just a short walking distance from the rocks in the previous painting. The tide was coming in, and to express the power of the water against the strength of the rocks, I used expressive brushstrokes and thicker paint.

Incoming Tide • *Oil on Masonite* • *6" x 9" (15cm x 23cm)*

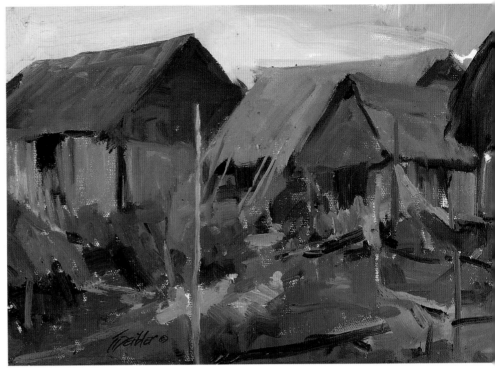

Ambassador for Painting

A few years ago, I spent some time in the Amazon Jungle painting in one of the remote villages. The people were very receptive and would watch every painting stroke I made from start to finish. Shown above are many of the village kids using watercolor paints that we brought into the village for an art day.

Go Somewhere New

When painting, first impressions are often the most truthful. When faced with a new environment of subject matter, try not to analyze it too much. Enjoy the newness and spontaneously react to it without any preconceived ideas. This was painted the first evening I was in the village previously mentioned.

The First Evening · *Oil on canvas* · *8" x 12" (20cm x 30cm)*

Using Complements

The brilliant sun shining on these tiny grass huts gives the feeling of a cheerful day despite the inhabitants' economic conditions. Note how the colorful red trim around the doorway and the green foliage complement each other.

Jungle Huts · *Oil on canvas* · *8" x 12" (20cm x 30cm)*

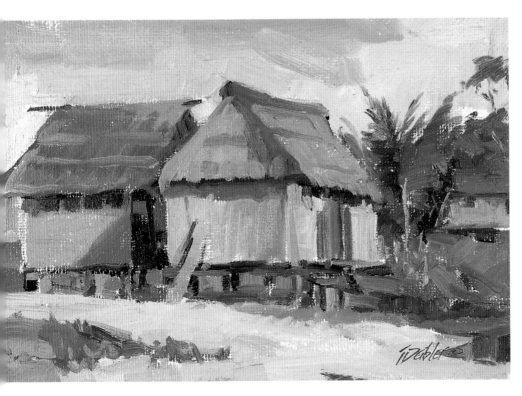

Patterns in the Sky

Clouds not only make great accessories for landscape paintings, but many times can be the main subject. Define the main direction of movement and pay special attention to any color or temperature changes in the clouds as they recede into the distance. Be careful with the use of hard edges; clouds need to be light and airy.

Cloud Patterns • *Oil on canvas* • *9" x 12"*
(23cm x 30cm)

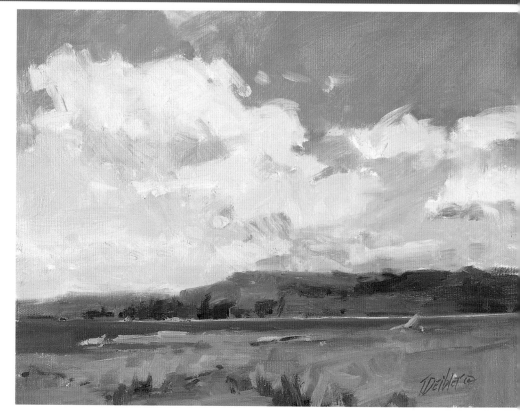

Less is More

Many times we complicate our paintings by adding too much information. Oftentimes deciding what to leave out is more important than what you put in. Aim for a simple statement. This painting contains enough information that it could be carried back into the studio and detailed all day long, but what's the point?

Winter in Colorado • *Oil on linen* • *9" x 12"*
(23cm x 30cm)

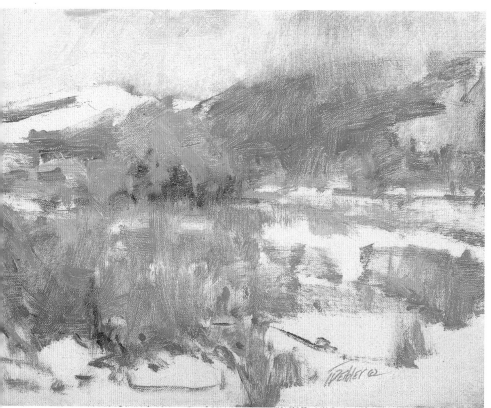

Reach for the Moon

This study was done as a demonstration piece for a workshop I was teaching. It was late afternoon when we arrived at our location and the moon was rising over the peak. Had we arrived a few minutes later, the moon would have been higher in the sky and not included in the painting. Place your finger over the moon and see if the painting has the same impact.

LaVeta Pass Study · *Oil on linen* · *8" x 10"*
(20cm x 25cm)

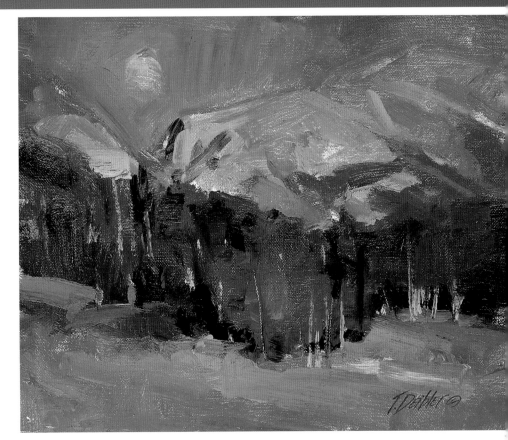

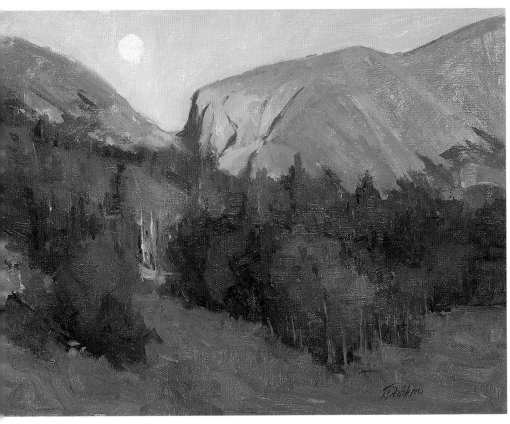

Taking it Further

This is the finished studio piece done from the location study. I photographed the mountains at different intervals while my group was painting and chose to do my painting later in the evening. The mountains have a soft, warm glow from the fading light while the trees are already lost in the cool shadows. The moon was very high in the sky at this point, but I placed it in its earlier position, completing the mood and giving the painting an air of mystery.

Where Two Mountains Meet · *Oil on linen* ·
12" x 16" (30cm x 41cm)

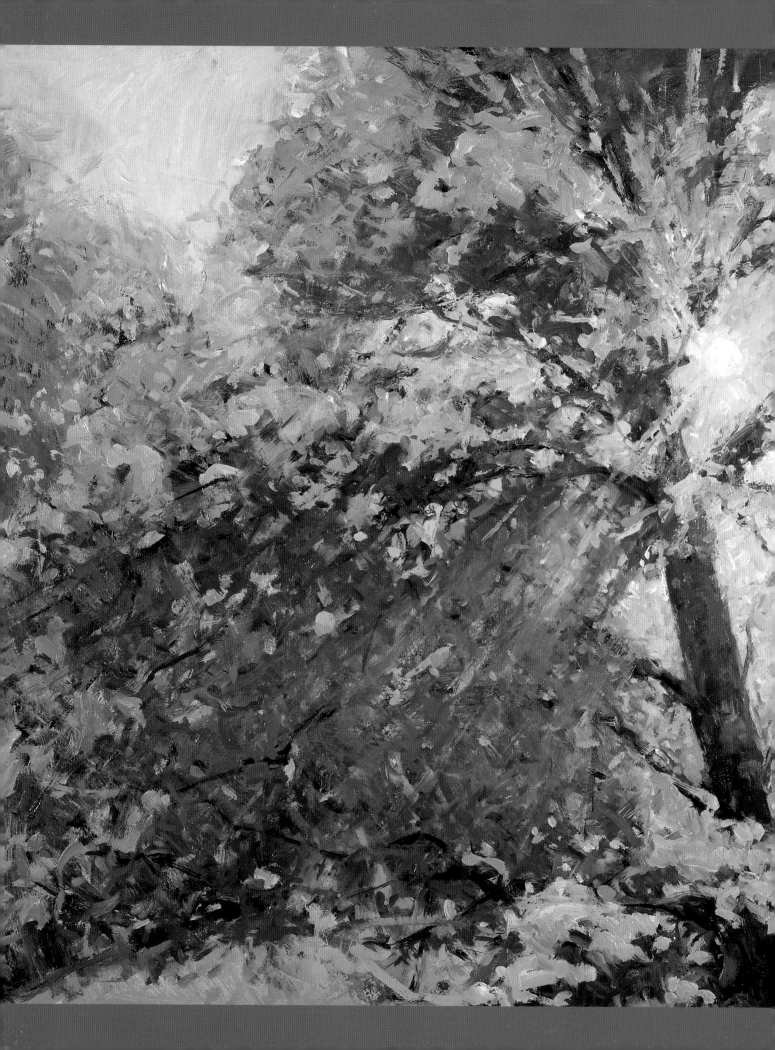

4

RECOGNIZING AND PAINTING SEASONAL LIGHT

In essence, no matter what style of art we paint in or what subject matter we choose, we all paint light. Without light we would have no visual perception. For landscape painting, the sun is our major source of light. Sunlight does some unusual things as it encounters different objects and particles in our atmosphere. Having a basic understanding of some of the principles of light will make it easier to depict what is happening visually.

Morning Sun • Oil on Masonite • 24" x 30" (61cm x 76cm)

A Look at the Seasons

As mentioned on page 28, our primary light source, the sun, does not change. The same sun shines on all parts of the earth, but the resulting climates vary considerably around the world. When it is summer in the Northern Hemisphere it is winter in the Southern Hemisphere; when it is day in your part of the world, it is night somewhere else. From the sun's standpoint, somewhere on the earth it is sunrise, noon, sunset and every hour in between simultaneously. Each hour of the day offers its unique color of light on the landscape. Here are a few simple, scientific facts to help us understand what is happening.

We all know that the earth is basically round like a ball and that it spins, or rotates, on its axis. This rotation is what causes the sun to appear to rise in the east and set in the west. The earth makes one complete rotation in 24 hours. The important thing to note about the earth's rotation on its axis is the tilt of the axis at about $23^{1}/_{2}$ degrees. It is this tilt that allows all of the earth to receive light and is responsible for our changing seasons. Not only does the earth rotate, it also revolves around the sun. Traveling at about 66,000 miles per hour over a path of 590,000,000 miles, it completes one revolution in $365^{1}/_{4}$ days, or one calendar year.

Generally the earth is 93,000,000 miles from the sun, but we do come as close as 91,000,000 in the winter. Here again the important thing for artists to consider is the $23^{1}/_{2}$-degree tilt. As the earth rotates and revolves, the axis always points in the same direction, toward the polestar Polaris, more commonly known as the North Star.

What this means is that during the course of a year, there is a period of time when the Northern Hemisphere is leaning closer to the sun and a time when the Southern Hemisphere is closer to the sun. There are also two periods of time when the sun is about equal on both hemispheres (creating spring and autumn).

Since the earth is round, parts of the earth face the sun more directly than others. Tropical areas face the sun for a large part of the year, making their climates very warm. Where the earth curves away from the sun the temperature drops, resulting in the coldest areas at the North and South Poles. To summarize, the tilt of the earth and its rotation, in combination with its revolution around the sun, create day and night and the changing seasons.

The Tilt of the Earth's Axis

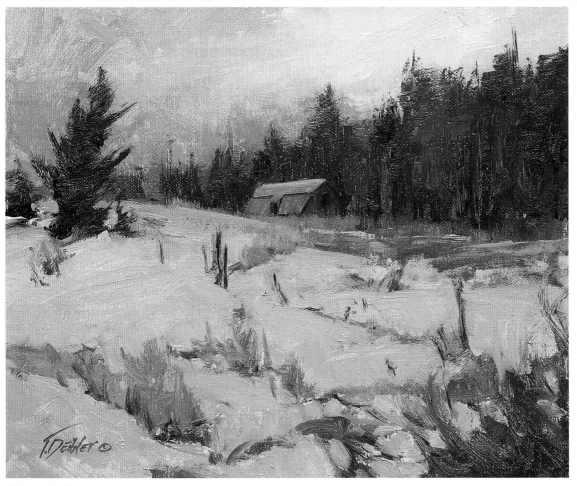

Winter Sunlight

Because of the earth's tilt, light from the sun is spread over a larger area in the winter months, making it less intense. This painting contrasts the weaker warm light of the sun with the cool violets of the snow. The use of yellow as a complementary color keeps the image from being too cold.

Waiting for Spring · *Oil on linen* · *9" x 12" (23cm x 30cm)*

September Morning

As the early morning sun starts warming the earth, the high concentration of water vapor in the rain forest starts to rise and fill the air, diffusing the light and softening the edges of nearby trees.

Morning · *Oil on canvas* · *8" x 12" (20cm x 30cm)*

A Look at Light

As the seasons change, the qualities of light seem to change also. For instance, the days in winter get shorter, the nights longer and the sun doesn't seem as intense. And for every other season you'll also notice differences in light quality. What is it that causes seasonal sunlight to differ so drastically?

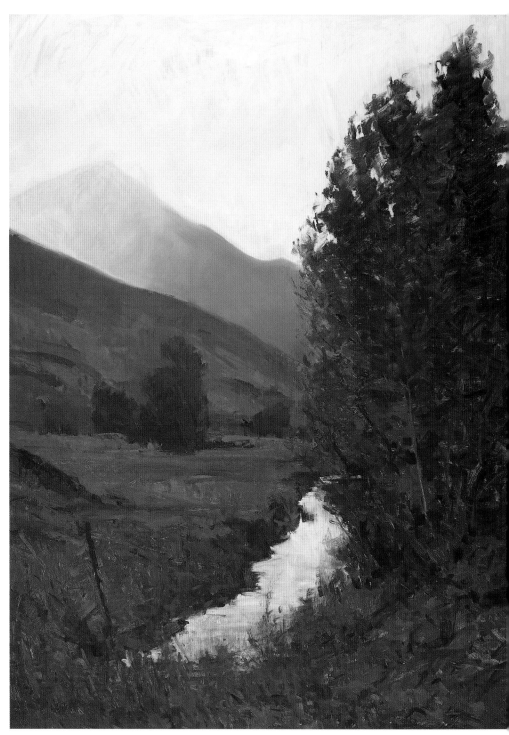

A Look at Light
As the late evening sunlight filters through a dusty atmosphere, the light rays are scattered, changing the appearance of a distant mountain into colors resembling a rainbow.

Summer Eve · *Oil on Masonite* · *40" x 30" (102cm x 76cm)*

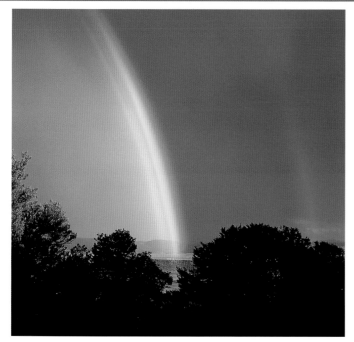

Nature's Prism—the Rainbow

Under the right circumstances, water droplets in the air can separate the different colors contained in sunlight so that we can see them individually, thus creating a rainbow.

Light Becomes Visible

Light rays become visible to the eye only when they hit an object. The moon is brightly illuminated and reflects light to the earth while being surrounded by the black void of space. Energy from the sun in the form of light rays reaches our earth in only eight minutes. The light rays travel through the black void of space and only become visible when they reach an object. When these light rays hit the atmosphere around the earth, the atmosphere holds the light and illuminates the earth.

Everything we see is a reflection of light rays from objects to our eyes. These visible colors of the spectrum correspond to different electromagnetic waves. The different colors that comprise white light have different wave lengths and frequencies, which cause them to scatter at different rates. The color changes we observe are a result of these differences in wave lengths and frequencies.

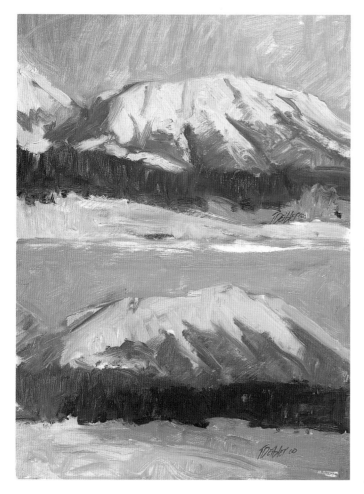

Always Changing

Doing quick studies to record the changing color of light is a great way to develop your skills of observation. The bottom painting was done immediately following the top one. As the sun began to set, the colors became warmer. Higher frequency colors (such as violet) drop out as light waves travel through the atmosphere. Violet tops the list of spectrum colors with the highest frequency and drops out very fast. On the other hand, Red has a very low frequency and can travel through a lot of atmosphere, which is why our sunrises and sunsets take on an orange-red glow. As the sun climbs higher in the sky around noon, the atmosphere is thinner and we see more of the different rays, thus creating a glaring white light.

Mount Maestas · *Oil on Masonite* · *12" x 9" (30cm x 23cm)*

High Humidity

Painting on days like this can be a real challenge—the coastal fog kept the visibility and the range of available values to a minimum—but the experience and rewards were well worth it. This is one of my favorite ocean scene paintings. I would have never been able to capture the value subtleties in the studio.

The Gulf of Mexico • *Oil on Masonite* • *9" x 12" (23cm x 30cm)*

Clear Skies

The brilliant sunlight and crystal clear skies gave me a full range of values and colors for painting this view of the Atlantic Ocean. Late in the day the warm color of the sun cast its magic light onto everything. As artists, we need to consider what time of day and what atmospheric conditions best describe our subject. As the angle of light and the atmospheric conditions change, so will the mood and key of your painting.

Daytona Beach • *Oil on Masonite* • *8" x 12" (20cm x 30cm)*

Choose Your Angle

Although most artists have their favorite times of day to paint, I think any lighting can make a strong painting. Certainly with sidelighting you can create dramatic paintings that reveal brilliant lights and strong darks. Backlighting produces subtle value changes and interesting silhouettes, while frontlighting saturates the subject with color, creating interesting shapes. You can infuse toplit objects with reflected light or seek out interesting light and shadow patterns. Try them all; don't fall into the trap of painting only one type of picture. Allow each of your paintings and studies to stretch your artistic abilities and vision.

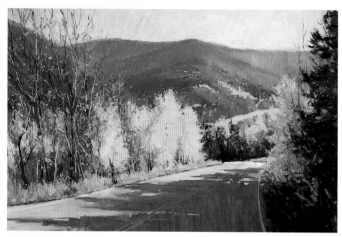

Sidelighting

Strong light and shadows are created when the light is coming from one side. Many artists prefer this type of light as it tends to be the most dramatic and reveals more of an object's three-dimensional form.

Aspen Highway • *Oil on Masonite* • *24" x 36" (61cm x 91cm)*

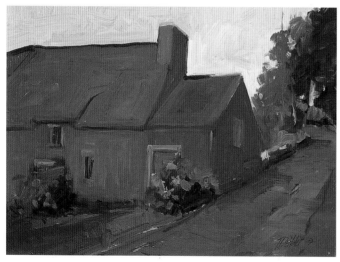

Backlighting

When the sun is behind your subject and in your eyes it creates backlighting. Backlighting casts the entire subject into shadow and illuminates only the outer edges and sky. This lighting creates a strong statement using a minimum of values at the opposite end of the scale.

Brittany Dusk • *Oil on Sentra board* • *9" x 12" (23cm x 30cm)*

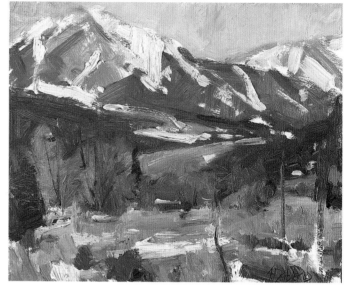

Frontlighting

When the sun is behind your back, striking the view head-on, you get frontlighting. Frontlighting reveals vibrant colors but few to no shadows. This type of light is great when painting interesting shapes and the natural patterns in nature.

Signs of Spring • *Oil on Masonite* • *8" x 9" (20cm x 23cm)*

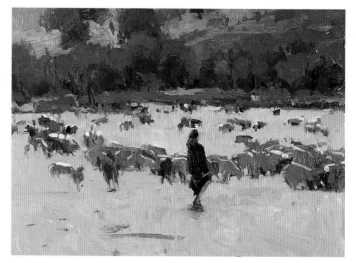

Toplighting

Around noon, when the sun is overhead, the direct sunlight illuminates only the top edges of things, leaving the sides in shadow. Look for reflected light bouncing into everything from the ground plane or other horizontal surfaces.

Bedouin Shepherd • *Oil on Masonite* • *11" x 14" (28cm x 36cm)*

Color In Shadows

Since light travels directionally and illuminates everything in its path, what it does not touch directly is left in shadow. A true shadow, void of any light, would be black. However, since our atmosphere holds light, nature bounces light and color into shadows through our sky and surrounding objects. Artistically speaking, since anything in shadow is not directly receiving warm light from the sun, it will be influenced by the cool light of the sky. If the sky is blue, there will be a blue influence to the shadows. Using this warm and cool contrast is vital if you want to create the feeling of light in your landscape painting. Since we do not see shadows as black, avoid painting them that way.

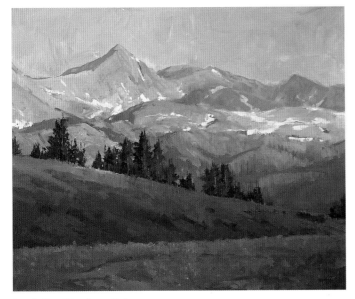

Look for Shadow Color
Shadows aren't always one solid color—look for colors that are reflected into them and paint what you see.

Shrine Pass · *Oil on Masonite* · *18" x 24" (46cm x 61cm)*

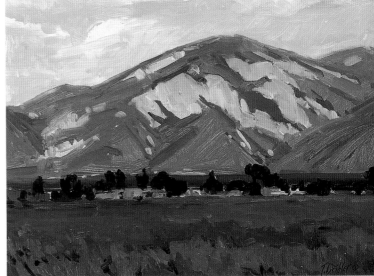

Color in Shadows
Foreground shadows retain more of the local colors present in the objects, but the shadow colors cool as they recede into the distance. The exact color of a shadow depends on the local color of the object itself and the color of light being reflected into it from the sky or surrounding objects. In most instances foreground shadows will be a darker, cooler value of the local color. Shadows, like any other object in the landscape, follow the same rules of aerial perspective. As objects recede they will get cooler and lighter in value, smaller in size and the edges will be softer.

Lengthening Shadows · *Oil on Masonite* · *12" x 16" (30cm x 41cm)*

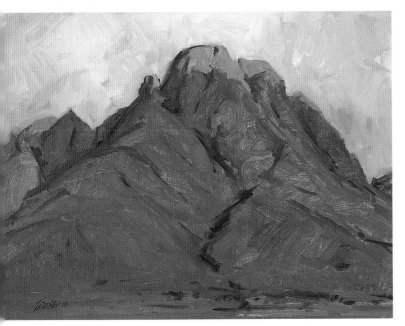

Accent the Shadows
The Sinai Desert is rugged with very little vegetation. During the final moments of sunset, the light is only on the very top of the mountain, leaving everything else in shadow. One important consideration for our shadow areas is the dark accent. These dark accents give form and luminosity to the shadows and should be as carefully considered as highlights in the light areas.

Mount Sinai Sunset · *Oil on Masonite* · *14" x 18" (36cm x 46cm)*

Painting Shadows

■ When painting landscapes, it is important to remember that the warm light of the sun causes cool shadows. Studio painting under north light produces the opposite effect, a cool light with warm shadows. In this demonstration our goal is to keep the warm evening light separate from the cool shadows.

MATERIALS

10" x 14" (25cm x 36cm) Gesso-primed Masonite panel

PAINTS
Phthalo Blue
Cadmium Yellow Light
Cadmium Orange
Naphthol Red Light
Ultramarine Blue
Titanium White

BRUSHES
Nos. 2 and 6 bristle flats

OTHER SUPPLIES
Paint thinner
Paper towels

Reference photo

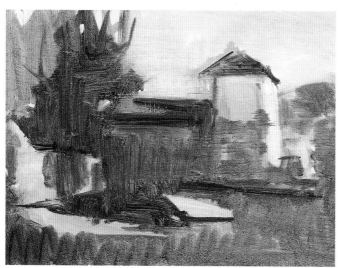

1 Start Thin

Use your no. 6 flat to lay in thin transparent washes of Cadmium Yellow Light and Cadmium Orange in the sunlit areas. The exact shape at this point isn't as important as keeping the warm/cool separation. Use blues, greens and purples to indicate the shadow areas. Connect the shadow areas regardless of object and allow the sunlit warm areas to be scattered, individual shapes.

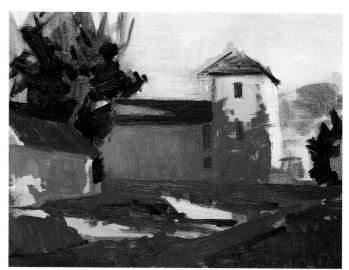

2 Paint the Shadows

Start working into the shadow areas with your no. 6 flat loaded with more paint. Paint into the washes and start defining some of the different shadow shapes using different color temperatures. To keep the shadows unified and reading as one mass, keep them simple. The darkest shadows are the tree shapes at each end of the building. Paint the side of the church using yellow mixed with a complementary violet made from Ultramarine Blue and red to dull it down. Look for color variations; notice that the wall is warmer on the left and cools as it moves to the right. The grass is loaded with lots of blue. Already there is a strong feeling of light as the thin warm washes interact with the cool shadows.

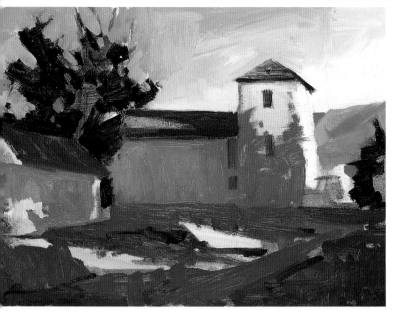

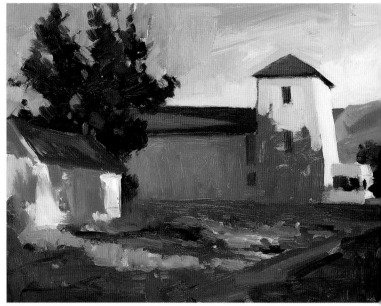

3 Paint the Sky

With a generous amount of paint, establish the sky. Start with a touch of yellow and lots of white to paint the warmest part of the sky on the far right. As you work to the left, away from the light source, add a touch of red and touches of Phthalo Blue. The sky is the darkest where it shows through the masses of leaves on the left side. As you paint the sky, define the shape of the church. The background mountain is simply indicated with a light and shadow shape made with Ultramarine Blue, orange, red and white. The blue dominates in the shadow while the warmer colors dominate the mix on the light side.

4 Paint the Light

Still using your no. 6 flat and lots of paint, establish the warm lights. Start on the front of the church with white and a touch of yellow for the lightest light. Add touches of orange and yellow to paint in other light areas. The sunlit grass is painted with yellow and Phthalo Blue. Keep the values high in the light areas to keep them separated from the darker cool shadows.

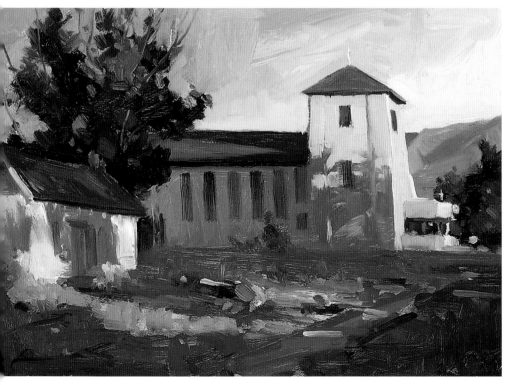

5 Finishing Touches

With the painting near completion, use your no. 2 flat to add windows, doors and other details. Stop when the statement is complete.

Reflections

Reflections always add interest to a painting, whether it is a puddle in the road reflecting a tree or part of a building, or a lake reflecting a panoramic view of a mountain range.

Water acts like a mirror reflecting light rays to our eyes. In almost all instances darker values reflect slightly lighter and light values reflect slightly darker than the object they are reflecting. As light rays hit water some of them are absorbed, thus narrowing the range of values. The color of the water also affects the color of the reflection. Colors reflected in muddy water will not be as shiny or colorful as colors reflected in clear transparent water.

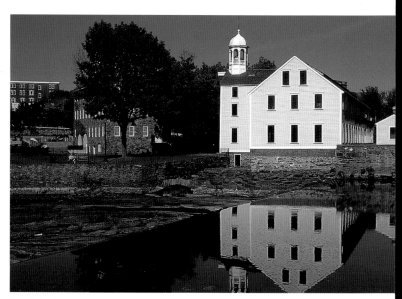

Double Image
Although interesting in a photograph, perfect or near-perfect reflections are not only difficult to paint, they can be uncomfortable to look at. Movement in the water from wind or anything that disrupts the surface will change, distort, blur or obliterate a reflection. To avoid confusion to the viewer, it is best not to have an exact mirror image of your subject.

Simplify Reflections
Although reflections are an important part of many landscape paintings, keep them simple unless they are the focal point of the piece.

First Light of Day · *Oil on Masonite* · *40" x 30" (102cm x 76cm)*

Changing Reflections

What you see reflected changes depending on your point of view. As you move around the scene or change your perspective of the scene (such as climbing a hill), the objects being reflected will also change. For a simple experiment with reflections, lay a mirror on a table and place different objects around it. Change your point of view in relation to the mirror and see how the reflections change. You might even try standing on a chair to get a view comparable to being on a hill looking down at a lake.

Ground Level
This photo was taken at an average eye level. The reflection is what you would see standing by a mountain lake.

Looking Down
From a higher vantage point looking down at the mirror, the reflection has changed considerably.

Painting Reflections

■ The best way to become acquainted with reflections is to paint them. After a summer rain or a trip to the lake, wherever you can find standing water, take the opportunity to study reflections. This demonstration will take you step by step through the method I use to paint convincing reflections.

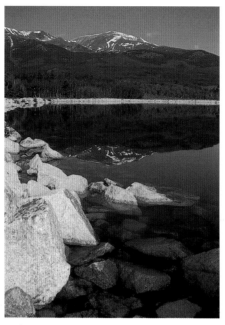

Reference photo

MATERIALS

11" x 14" (28cm x 36cm) Gesso-primed
 Masonite panel

PAINTS
Phthalo Blue
Cadmium Yellow Light
Cadmium Orange
Naphthol Red Light
Ultramarine Blue
Titanium White

BRUSHES
Nos. 2 and 6 bristle flats

OTHER SUPPLIES
Pencil
Paint thinner
Paper towels

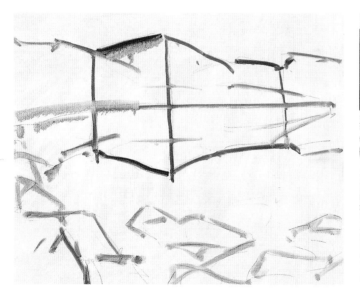

1 Accurate Placement
With a pencil, quickly sketch the object and its reflection. Accurate placement of the reflection is important to the believability of your painting. Thin Ultramarine Blue with your paint thinner and go over the pencil lines so they are easier to see. Place vertical lines from the subject running into the water so that the reflection is under the object being reflected. The more complex the reflection, the more important the preliminary planning.

2 Paint Object and Reflection Together
With your no. 6 flat, mix and apply a basic mountain color. Use Ultramarine Blue, orange, red and white and paint the mountain boldly and simply, leaving out details like the snow. Using the same colors, paint in the reflection. If the value or color of the reflection is different from the object, make the necessary changes before you paint the reflection.

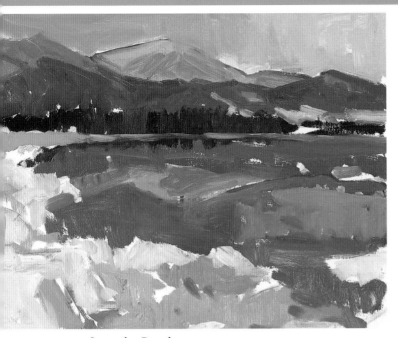

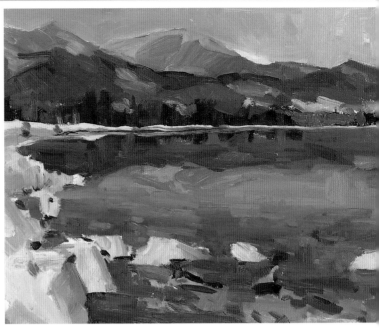

Cover the Board

3 After painting the reflections, start to fill in the remaining areas of the painting surface using your no. 6 flat. Work quickly and lay in large areas of color. The sky is lighter on the right side and is painted with a touch of yellow and red in a light blue mix of Phthalo Blue and white. As the sky moves to the left it darkens; add more Phthalo Blue and at the edge where it is darkest add some Ultramarine Blue. Mass the water in using a slightly darker value of the sky colors. The water is darkest in the foreground. Mix Ultramarine Blue, orange and red with lots of white to paint in the rocks. Remember to keep the shadow side cooler.

Slow Down

4 When the entire board or canvas is covered, slow down and start working with the edges and values. Now is the time to start refining shapes, making sure they are clear. Carefully observe your painting as a whole; do you need to adjust any of the values or the reflection? Short horizontal strokes can blur the edges if the reflection gets too busy or exact. Having rocks in the water helps break up the water's surface and keeps the reflection in the water.

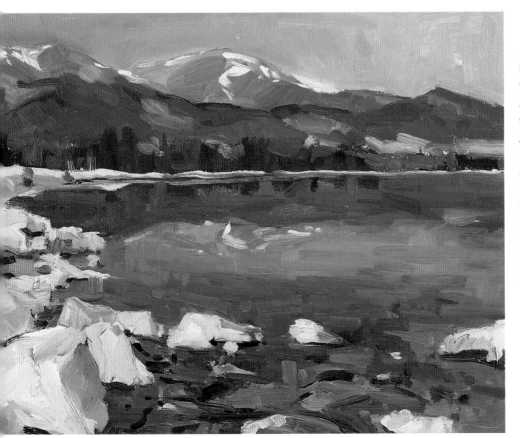

Add Details

5 Now with your no. 2 flat, go back and add some dark accents with Ultramarine Blue, red and orange around the rocks and in the water. These dark accents will give the rocks weight and will make the water look transparent. After I finished this demo painting, I noticed that the mountain reflections are a touch warmer than the mountains and not quite large enough. Should I cool the reflection? How about darkening its value? Now is the time to make these crucial decisions. This is the refining stage where you can take the painting to whatever degree of finish you prefer.

Color in Foliage

Trees are living things and are about as individual in their shape and size as are people. Trees in the same species will vary in their characteristics, so look carefully at the tree you are painting and try to emphasize its unique features. Trees in nature aren't all perfectly shaped like an idealistic Christmas tree.

Deciduous trees present us with spectacular autumn foliage. Leaves produce food for the tree through the process of photosynthesis. In order for this process of making food to work, leaves use a substance called chlorophyll. The green chlorophyll gives leaves their summer color. Other colors are always present in leaves but are blocked by the chlorophyll. Near the end of summer, as the tree starts preparing itself for winter, it grows a wall of cork cells at the base of each leaf stem and cuts off the flow of water and minerals to the leaves. Without water the chlorophyll fades and disappears, revealing the yellow and orange pigments. In Colorado we have the aspen tree whose leaves turn a brilliant yellow-gold; other trees, such as the maple tree in the New England states, turn a bright red. Species of trees vary in every part of the world, so study the trees in your area to familiarize yourself with each species and learn how to best portray them in your art.

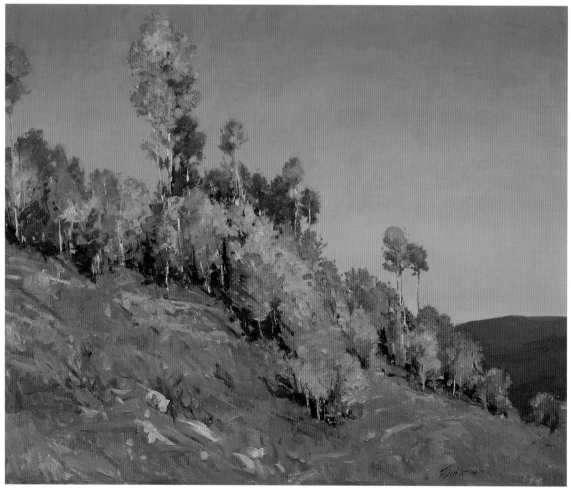

Color Creates Impact

The variety of colors in the autumn leaves makes this painting interesting. If I had waited until all the leaves were the same color, much of the rhythm and impact of this composition would have been lost.

Changing Seasons • *Oil on Masonite* • *24" x 30" (61cm x 76cm)*

Seasonal Differences

Spring leaves usually lean toward a yellow-green color. Because the color is more translucent, the sunlight easily passes through the leaves, making them appear lighter in value. As summer approaches, leaves become a darker green and may lean more to the cool side. In autumn the green chlorophyll fades, revealing yellows, oranges and reds. By winter most of the leaves have fallen or have turned brown and the tree becomes dormant.

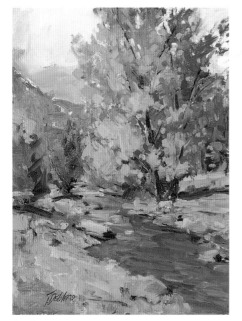

Spring

Summer

Autumn

Winter

Taking a Closer Look

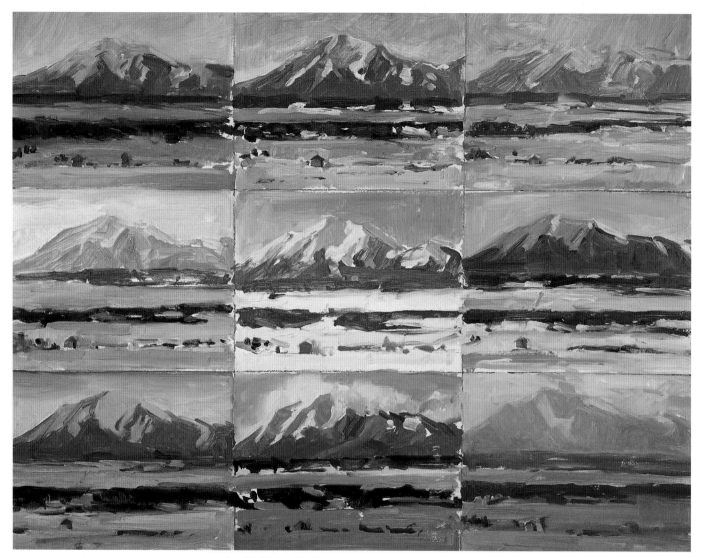

Multiple Studies

To really get an in-depth understanding of a subject, I recommend doing a series of studies from the same vantage point, at different times of the day and month. The paintings in this panel are all 6" x 8" (15cm x 20cm) and were done in fifteen to twenty minutes. I recorded these images from life in February, during different times of day and weather conditions. I used one 18" x 24" (46cm x 61cm) panel and divided it into sections with pencil lines. This allowed me to paint one image next to another without a space. If you prefer a little space around each individual study to separate them, divide your panel with masking tape and, when finished, just remove the tape. The purpose of these studies is to become observant—to observe the changes in the subject, not to create a finished painting. The more you learn and understand, the more you will be able to incorporate that knowledge into your finished work.

The East Spanish Peak in February • *Oil on Masonite* • *18" x 24" (46cm x 61cm)*

Gallery

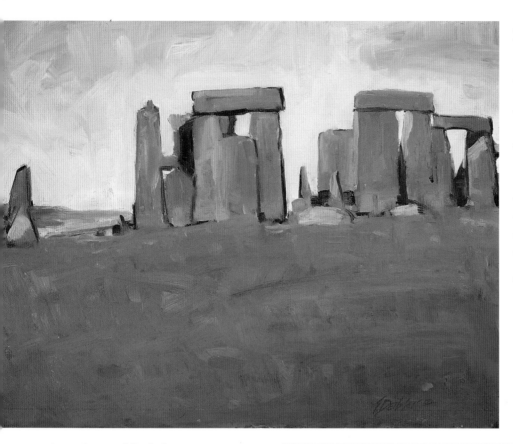

A Sense of Place

This ancient megalithic monument stands out boldly against the light-filled sky. The angle of the sun had a flattening effect on the scene creating two distinct values, the light sky and the darker ground plane. I painted these massive stones the same value as the ground which made them seem like part of the earth. It took the addition of some dark accents to help define the stones and give them form and weight. The dullness of the color scheme gives this painting a feeling of mystery and uncertainty.

Stonehenge · *Oil on Masonite* · *12" x 16" (30cm x 41cm)*

Importance of Dark Accents

The clear, crisp warm colors of the cliffs give this scene the feeling of a bright sunny day. As in the previous Stonehenge painting, it is the use of shadows and accents that gives the cliffs form and dimension. It took the coolness of the shadows and sagebrush to keep this painting from feeling too hot.

Cliffs at Abiqui · *Oil on Masonite* · *18" x 24" (46cm x 61cm)*

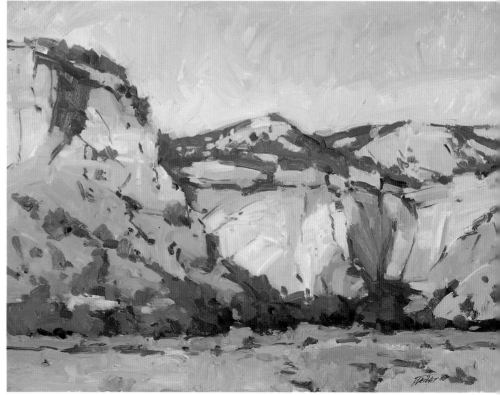

Atmospheric Conditions

Mount Maestas takes on many different looks depending upon the angle from which you view it. (Remember the painting of Mount Maestas on page 83?) From this particular viewpoint it looks like a perfect pyramid. The atmosphere was filled with smoke from nearby fires that gave the sunset a mysterious glow, changing a difficult compositional view into a spectacular new world.

Colorado Pyramid · *Oil on Masonite* · *12" x 16" (30cm x 41cm)*

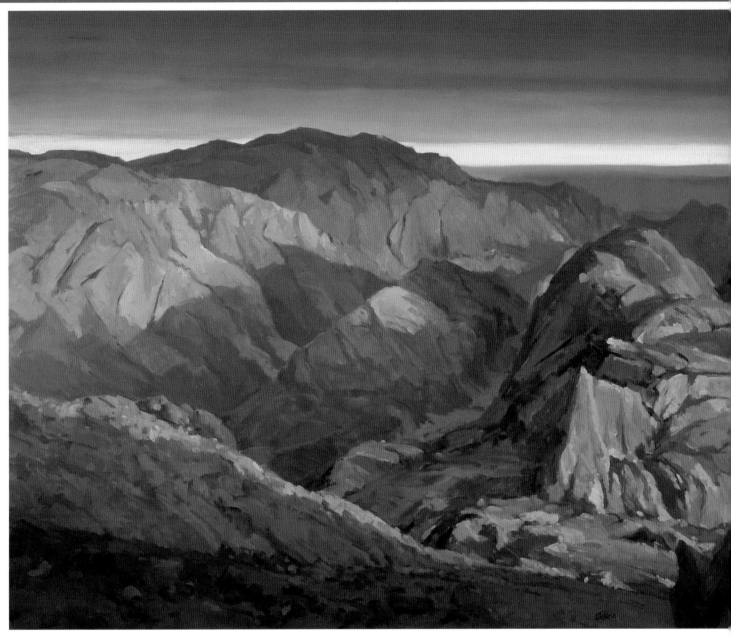

Get Up Early

The reward for starting our hike before dawn was this incredible sunrise view from the summit of Mount Sinai. The early morning sun bathed the desert mountains in a warm light which was complemented by the deep blue of the sky. The foreground shadows and edges are very dark and hard compared to the distant shadows, creating the feeling of space.

Sunrise From Mount Sinai · *Oil on canvas* · *36" x 48" (91cm x 122cm)*

Warm and Cool

As the final rays of the afternoon sunlight strike the building facades on this narrow street in Venice, it creates a striking warm glow. Everything not receiving this direct light is left in a deep, cool shadow.

Venice • *Oil on Masonite* • *16" x 12" (41cm x 30cm)*

Poetic Light

The strong colors of this evening light are intensified by the almost silhouetted forms of the trees against them, changing the scene into a magical moment in time. The foreground shape is kept intact by its value even though there is tremendous variety in color.

As Evening Falls • *Oil on Masonite* • *24" x 30" (61cm x 76cm)*

5

PAINTING THE POETRY OF THE SEASONS

Nature is constantly giving us a gold mine of inspiration as we walk through the changing seasons. Scenes take on countless variations as the time of day and year change. What today may be shimmering gold trees in the crisp autumn air, will tomorrow be subtle shades of gray as winter wraps its cold cloak around the landscape. Whether you're painting snowcapped mountains, the desert in bloom or vast grass-lands, in the midst of this constant change lies the true beauty of nature.

Niagara Falls • *Oil on Masonite* • *24" x 30" (61cm x 76cm)*

Getting to Know Your Subject

As well as being familiar with your mate-rials and equipment, it is extremely helpful to also be familiar with a specific location that you want to paint. Repeated visits can help you portray not only the look but also the essence of that location.

The location I've chosen for this series of seasonal demonstrations is a particular favorite of mine. I've passed this way hundreds of times and every time it offers something new and inspiring. Sorting through dozens of photographs and painted studies, I've selected an image from each season that portrays the spirit of that season. Included on this page are some of the photographs I have taken.

For the demonstrations in this chapter, I've rearranged the size and shapes of the foreground bushes and the rock outcroppings on the distant ridge, and I've varied the sky with clouds and without clouds. The variations in a special scene are endless for the creative artist.

The most important aspect in all of these demonstrations is the development of the painting as a whole. In order to bring the entire picture into focus at the same time, it's best to work on all areas of the canvas simultaneously. If you focus on a painting one small area at a time, you may end up with a painting full of little pieces that don't relate to each other. By developing the painting all at once, you will end up with a painting where every area is vital to the entire statement.

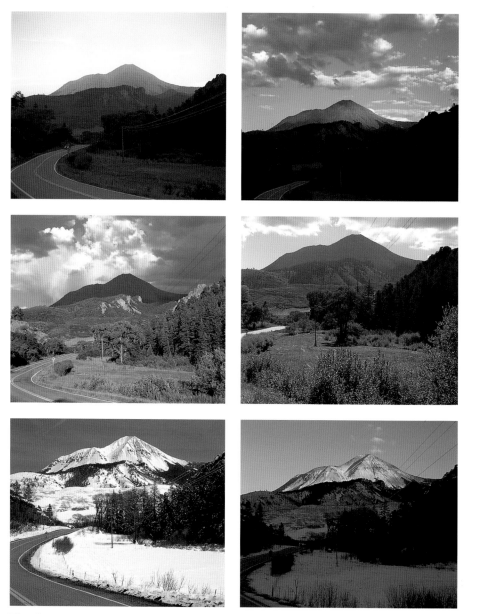

The Gap

The location is called "The Gap" by the local population. It's a place in the Dakota Sandstone Formation (which runs from Mexico all the way to Canada) where the Cuchara river has cut a gap in the wall. These sandstone walls frame one of the most incredible views in the entire valley of the West Spanish Peak, which rises to a height of 13,626 feet. The Dakota Sandstone Formation was broken and turned vertical as the mountains were formed and, though most of it is underground, there are several places in Colorado where it is visible; perhaps the most famous is the Garden of the Gods in Colorado Springs.

Here are samples of studies I have made of "The Gap." I encourage you to visit, take photographs and do studies to become familiar with a location. Then take those photos and studies and create a beautiful painting that inspires and brings the viewer into the scene.

Firsthand Experience

Although the following demonstrations were done in the studio, I have climbed this peak several times with my son, Stephen. This firsthand experience with the mountain makes these paintings more than just a copy of a photograph. I recently had someone in my studio tell me that my paintings convey the feeling of what it is like to be there. Transferring your inspiration into a painting that makes the viewer feel what it's like "to be there" is what landscape painting is about.

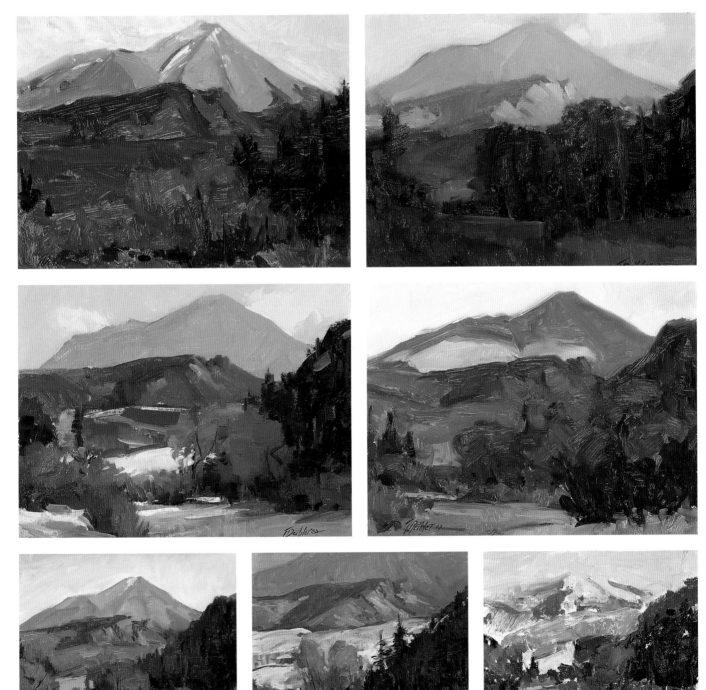

Painting Autumn

■ Nothing quite compares to the brilliant colors of autumn. As the trees prepare for winter, they put on their brightest show, portraying an awesome glow as the sun shines through their leaves. Capturing their brilliant colors with paint certainly is one of the most difficult challenges for the landscape painter. By using transparent and opaque colors as shown in this demonstration, the task becomes easier.

Begin this painting by carefully blocking in the shapes with transparent washes approximating the final colors.

Reference photo
When shooting a photograph straight into the sun, it is often helpful to place your hand or other object over the top of the lens to try to reduce lens flare.

MATERIALS

24" x 30" (61cm x 76cm) Linen panel

PAINTS
Phthalo Blue
Cadmium Yellow Light
Cadmium Orange
Naphthol Red Light
Ultramarine Blue
Titanium White

BRUSHES
Nos. 4 and 8 bristle flats

OTHER SUPPLIES
Paint thinner
Paper towels

1 Outline Shapes
Using a no. 4 flat, sketch in the major geometric shapes of the composition using Naphthol Red Light thinned with paint thinner. This sketch will act as a guide for the transparent washes you will be using.

2 Transparent Yellows
Switching to the no. 8 flat, dilute Cadmium Yellow Light with paint thinner and block in the brightest areas of the autumn foliage. It is important at this stage not to add any white to the yellow; once white is added, the yellow becomes opaque. Opaque paint will reflect light back to the viewer rather than allowing light to penetrate through the yellow to reflect the white surface of the canvas.

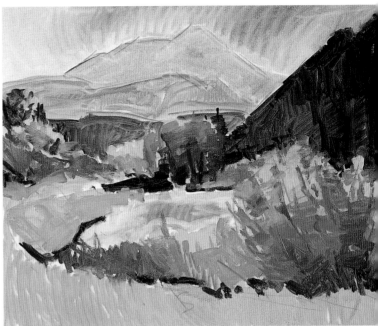

Continue Transparent Washes

3 Still using only transparent washes (no white added), cover the entire canvas with colors and values that approximate the final colors. Use various mixtures of Phthalo Blue and yellow for the green grass, and use Ultramarine Blue, Phthalo Blue and red with slight touches of orange to establish the darker values.

Paint Mid-Values

4 Focusing now on the middle values, using mixtures of orange, Ultramarine Blue and yellow, start applying thicker paint on the center trees with a no. 8 flat. Using slight variations of the same mixtures, also work on the bushes in the front, aiming for accurate color.

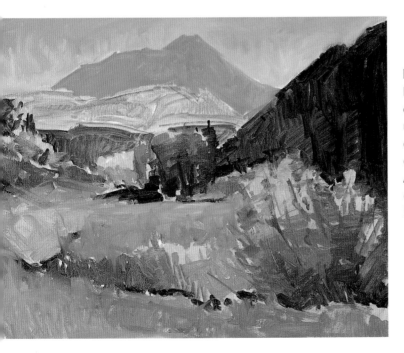

Add White

5 Still using a no. 8 flat and thicker paint, establish the ground plane by painting the field and grass around the bushes with mixtures of red, yellow, Ultramarine Blue and Phthalo Blue plus white. Essentially every color on your palette can end up in these mixtures. Paint the sky in a very light value using Phthalo Blue, Ultramarine Blue and white. (Because I didn't thoroughly clean my brush, a slight amount of yellow-orange gave the blue on the right side a light, greenish tint.) Add a touch of red to both of your blues to create a slightly darker value than the sky, and paint the mountain. Keep the left side of the mountain slightly cooler with more blue.

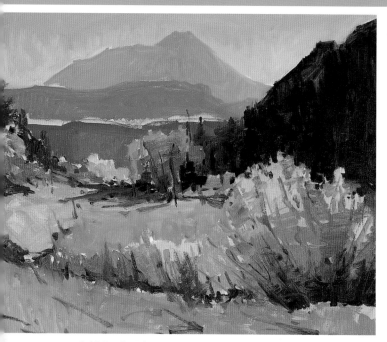

6 Add Dark Values

Mix darker values of Ultramarine Blue, red and orange into the mountain mixture to create the darker value of the middle hills. Add some white into the mixtures to maintain the proper value, at this point the transparency is lost. You want to get the entire value range working now, so add the darks of the hill on the right and some accents in the bushes with mixtures of Ultramarine Blue, orange and touches of red and Phthalo Blue. Getting all the large masses and values in early makes it easier to judge the entire painting before adding details. If any major change is necessary, it should be obvious at this point.

7 Develop Foliage

With strokes of yellow and orange, start reshaping the cottonwood trees near the center. Add red to the yellow and orange and start working on all the trees and bushes in the painting, paying careful attention to the color changes in them. Continue using a no. 8 flat to keep shapes strong and simple. The grassy areas are developed further with different mixtures of green and touches of orange. Edges are being considered now; some are strengthened but most are kept soft to allow the eye to move through the painting easier.

8 Correct Values

Even though the sun is high and backlighting everything, the dark ridge should still have a minimal amount of form and color in it. With the no. 8 flat, indicate some trees receiving backlight; this helps to give the ridge some depth. Orange mixed with both blues pulls out the tree shapes, while mixtures of red, Ultramarine Blue and orange make a dull purple that indicates the rock formation in that ridge. Repaint the background hills using the original mixtures from step 6. Use extra care to leave some of the original yellow wash showing through to create the top edge of the hills. The value of the peak is lightened to give a feeling of more depth and the edges are softened. (I decided to wipe out an area of the brush in front to allow the viewer to enter the scene easier.)

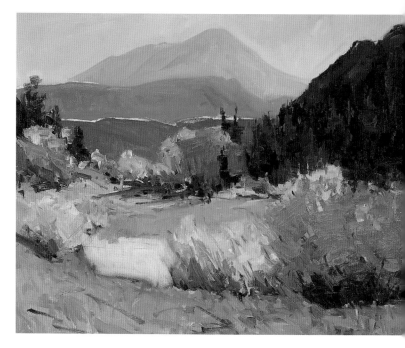

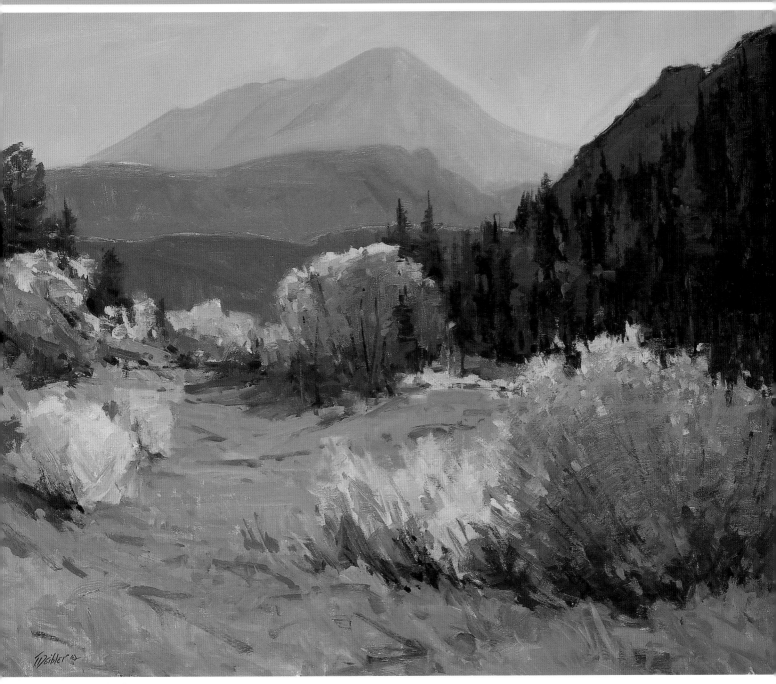

9 Final Adjustments

The section of brush that was wiped out has been replaced with grass, giving the viewer a path into the painting. If the ridge on the right still seems too dark, lighten the trees a little more. In order to keep the feeling of the backlight, you can strengthen the darks in the shrubs. Edges of the different bushes and hills are highlighted to help reinforce the angle and direction of light. A light mixture of yellow-orange is worked into the right side of the peak to warm it slightly also. A few tree trunks have been added for details.

The Gap—Autumn • Oil on linen • 24" x 30" (61cm x 76cm)

Painting Summer

■ If nature had a favorite color, it would certainly have to be green. Summer abounds with green, much to the artist's dismay. Most artists have more difficulty mixing green than any other color. Premixed tube greens may be helpful in some situations, but they can also lead to more frustration.

I look at greens in two different ways: how warm or cool they are or how bright (intense) or dull (grayed down) they are compared to their surrounding colors. Comparing the color temperature of the greens with other colors around them will make them (or any color) easier to mix. This demonstration will give you plenty of practice in mixing a variety of summer greens with our limited palette.

MATERIALS

24" x 30" (61cm x 76cm) Linen panel

PAINTS
Phthalo Blue
Cadmium Yellow Light
Cadmium Orange
Naphthol Red Light
Ultramarine Blue
Titanium White

BRUSHES
Nos. 2 and 8 bristle flats

OTHER SUPPLIES
Paint thinner
Paper towels

Reference photo

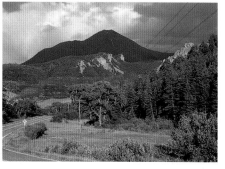

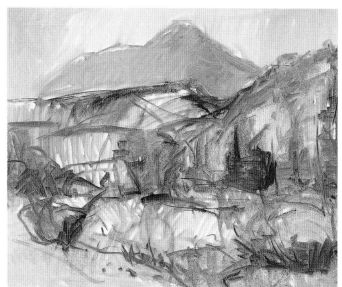

1 Start with Complements
Beginning with a no. 8 flat, thin Cadmium Orange with paint thinner and block in the sky and distant mountain peak. As a complement to the green summer foliage you will be adding, use Naphthol Red Light (also thinned with paint thinner) and block in the remainder of the composition. Begin thinking in terms of value and start to suggest some of the darker masses in this initial block-in.

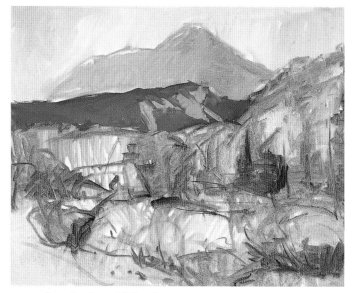

2 Start in the Middle Distance
Starting with the middle ridge, mix up orange, Ultramarine Blue and yellow with white and paint the rock outcroppings first. Working out from the rocks, mix up a green from Ultramarine Blue, yellow and white. This green won't be quite as bright as the foreground green for two reasons; first, the red properties in Ultramarine Blue, also, some of the red block-in will mix with the green and tone it down even more. Thats okay, since you want to keep the more brilliant greens in the foreground. There are a lot of subtle color changes in this ridge but the important thing now is to find the average color and value. The specific color temperature and value can be corrected later if necessary.

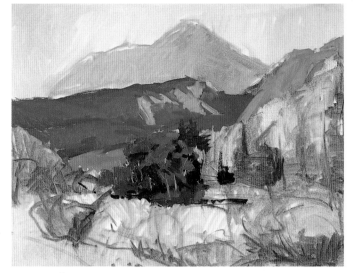 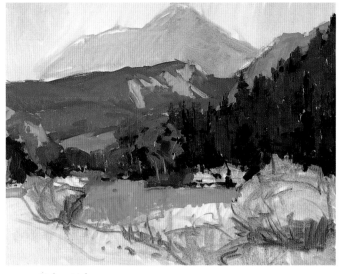

Making Greens

3 Continuing with the same green mixture and your no. 8 flat, add a touch more of yellow and paint the ridge in front. Add a slight touch of Phthalo Blue toward the bottom of this hill to bring it forward. Mix orange and yellow with Ultramarine Blue and white to make a warm rock color for the rocky ridge on the right. With a strong bright green made of Phthalo Blue and yellow, start to suggest the central cottonwood trees, the ~~real darks in and around them. The darks~~ marine Blue, orange and red.

Using Values

4 Still working only with your no. 8 flat, block in the dark shadows of the pine trees on the right and indicate a sense of light and form by using various shades of green on the lighter sides. Some trees will have more orange in them, others more yellow or blue. You can get a lot of variety in your greens by contrasting cool greens (greens dominated by blues) with warm greens (greens dominated with yellows and oranges). How warm or cool a green is depends on the color temperature of what it is compared with. Now adding lots of yellow and a touch of Phthalo Blue to white, paint in the ground plane keeping in mind it will be the lightest area in the painting except for the sky and clouds. Getting the full range of values going early on makes it easier to compare different areas and make any necessary corrections. It helps bring the painting to life more quickly.

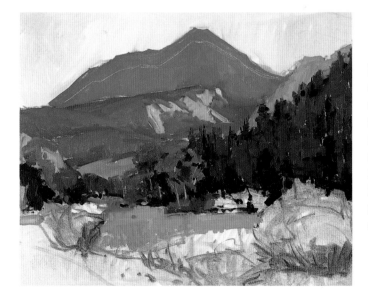

Paint the Distance

5 To have everything working together, begin with the mountain and sky. The mountain is in shadow so it will be painted darker than the ridge in front of it. Using mixtures of Ultramarine Blue, orange, red and white, start painting the shape of the peak. The orange wash originally used to indicate the mountain peak is still wet enough that it is mixing with the mountain color, slightly altering it. If it changes too much, lay additional strokes of blue over it to get the desired color. (Once I had the peak in, I realized I had made it too large. Using the handle of my brush, I scratched into the wet paint and redrew the mountain smaller. Before painting the sky I wipe off the excess with a paper towel.)

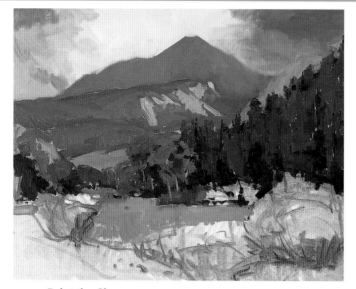

6 Paint the Sky

Now paint the lightest part of the clouds right up to the mountain using a mixture of orange, yellow, red and white. For the darker clouds, add in the original mountain color mix from step 5 and use more Ultramarine Blue and a small touch of yellow. To give even more depth to the sky, paint some blue sky showing through the clouds using Phthalo Blue and white. Keep the edges of the mountain soft where the value is near that of the sky and more defined where the sky is lighter.

7 Cover the Canvas

Use both blues along with yellow, orange and white to make a variety of greens and cover the remaining areas of canvas still blocked in with red. Paint the bushes on the cool side with a darker mixture of Ultramarine Blue, yellow and orange. Add some real strong darks with Ultramarine Blue and a touch of red under the bushes to define their form. Give lots of variety to the warm greens of the grass by usi̇ng differe̱n̲t̲ amounts of yellow and orange mixed with eit̲ ̲ ̲to̲ ̲. At this point, hints of the red underpainting ̲ ̲ ̲.̲le ove̲ much of the canvas.

8 Adjust Temperature and Add Details

Once the entire canvas is covered and you are pleased with all the shapes, begin to adjust some of the color temperatures. (I thought the foreground greens were too warm to represent the feeling of summer that I was after. Using more Phthalo Blue, yellow and white I worked back over the grass to lighten and cool it slightly.) Use short, scrubby strokes in the bushes; this not only changes the color but also gives them a leaf-like quality. Strokes of pure Ultramarine Blue are used in the shadows resulting in a cooler feeling.

9 Add Details

Returning to the rock face, begin working on the details that will bring the painting to a finish. Using a no. 2 flat, mix up a highlight color for the rock face using white and orange and just a touch of Ultramarine Blue to gray it slightly. Use short directional strokes to give it a rocky angular feel. Add additional details to the rock wall and the pine trees on the right. Mix a gray with Ultramarine Blue and orange and paint in a few tree trunks and branches. Carefully scrutinize every shape to make sure it is exactly what you want.

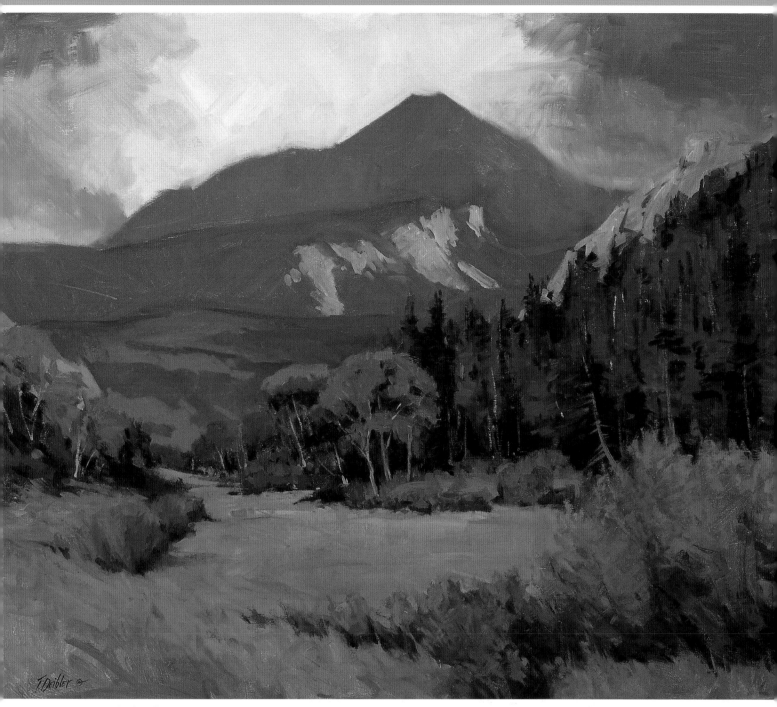

10 Final Refinements

I decided to change the angle of the lower slope of the front ridge from the left to the right to help keep the viewer's interest in the foreground longer. Additional strokes of varying color were added to the foreground bushes to give them more variety and interest. The blue of the sky was integrated by bringing some of the cloud over it, creating a smoother transition.

The Gap—Summer • *Oil on linen* • *24" x 30" (61cm x 76cm)*

Painting Winter

■ Each of the seasons has its own sense of magic. Winter happens to be my favorite time to paint outside because nature seems to outdo herself during this time of year. Fresh snow falls to the ground and blankets the earth in white, transforming the often complex forms into a single simple shape and value. Warm and cool colors find their greatest contrast in the warm light of the sun against the coldness of shadows. In this demonstration, you will learn how to contrast this warm and cool light.

This painting will begin very simply using orange to represent the sunny areas and blue to represent shadowed areas.

MATERIALS

24" x 30" (61cm x 76cm) Linen panel

PAINTS
Phthalo Blue
Cadmium Yellow Light
Cadmium Orange
Naphthol Red Light
Ultramarine Blue
Titanium White

BRUSHES
No. 8 bristle flat

OTHER SUPPLIES
Paint thinner
Paper towels

Reference photo

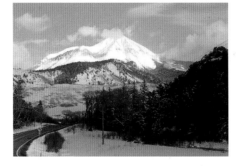

1 Light and Shadow
Beginning with the no. 8 flat, thin Cadmium Orange with paint thinner and block in the sky area as a simple rectangle. This orange wash represents everything in the painting that will be in sunlight. Use thinned Ultramarine Blue to block in all the area in shadow. At this point, your concern is only the division of light and shadow, so keep it simple, abstracting it down to two simple shapes.

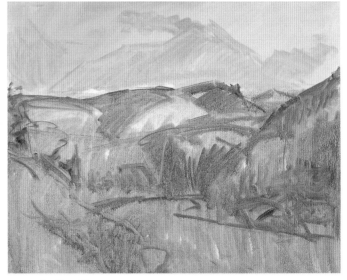

2 Define Shapes
Continuing with only Cadmium Orange and Ultramarine Blue (no white), further divide each section with additional shapes and values representing the different objects in the composition. Use only orange in the orange rectangle and only blue in the blue section.

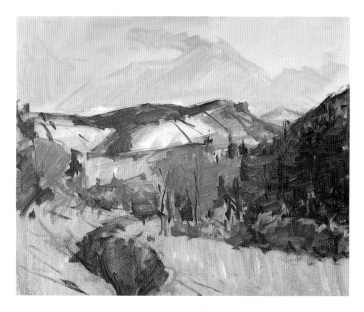

Work on the Shadows

3 Up to this point both areas have been equally developed, but now focus on the shadow area and start developing it further. Still using the no. 8 flat, mix up a red color for the willows using Ultramarine Blue and red. This set of willows acts as the lead-in into the painting and also adds a warm note to the shadow areas. Mix white with touches of yellow, orange, red and Ultramarine Blue and brush this into the bare cottonwood trees. Use a dark mixture of Ultramarine Blue and orange to indicate the tree-covered slope on the right. The shadow area takes up a lot of the canvas, so try to keep as many values and temperature changes in the shadows as possible without confusing them with the sunlit areas. The original blue wash already there is close to the value you need for the snow, so leave that area alone and turn to the sunny area.

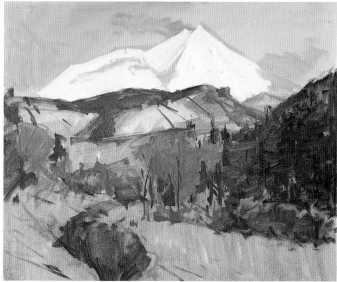

Work on the Light

4 Emphasize the snowcapped peak in this painting by taking a generous amount of white and a slight touch of yellow and firmly establishing the snow-covered slopes of the mountain with a no. 8 flat. Some of the orange wash mixes with the white and slightly warms it. Use Ultramarine Blue and white to indicate the cloud shadow on the snow.

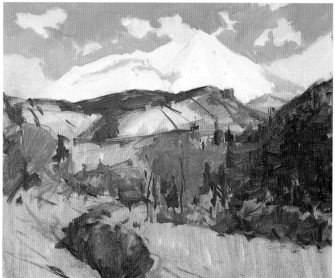

Paint the Sky

5 Staying in the light area, use lots of white with touches of orange and Ultramarine Blue to paint in the cloud patterns. When painting clouds, it is easier to keep the color clean by painting the clouds first, then the blue sky around them. A slight touch of yellow was mixed with Phthalo Blue and white for the lower part of the sky and Ultramarine Blue was added to Phthalo Blue toward the upper portion. Paint the blue in loosely around the clouds and blend it into the clouds to reshape them as the painting develops. By now the entire concept for the painting is visible and I can start making the necessary decisions to finish.

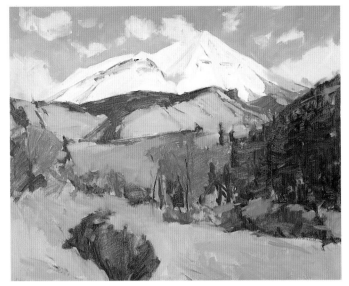

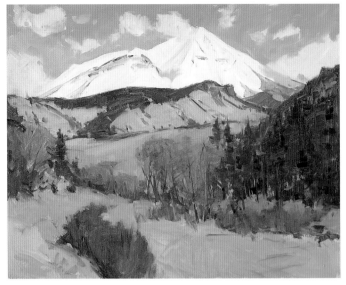

6 Develop the Entire Canvas
Place a few dark accents on the mountain to give it more form and soften the edges of the clouds by blending the blue sky into them. With mixtures of white, Ultramarine Blue and red, start painting in the snow-covered slopes and ground. You want to develop the entire canvas at the same time, so you will be painting back and forth into the light and shadow areas.

7 Refine Shapes
The ridge dividing the light and shadow areas is one of the key parts of the shadow, so begin indicating more of its characteristics and work your way down through the painting, refining the shapes of the trees and bushes. Keep the shadow area simple so as not to distract from the strong light on the mountain. The information in the shadows needs to be believable, but not completely described in detail.

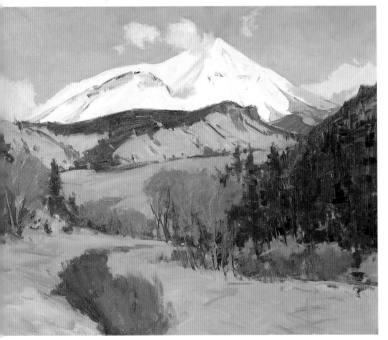

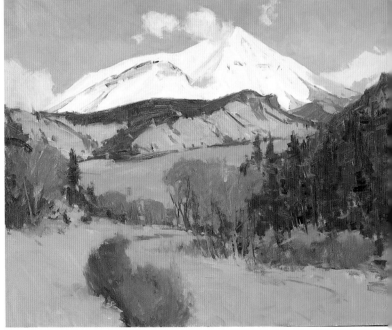

8 Simplify
If you don't like the small scattered clouds (as I didn't), go back in with more blue paint (see step 5) and simplify the sky by taking some of them out. Depending on the thickness of the cloud color, it may be necessary to wipe the clouds out with a paper towel or scrape them with a palette knife first. At this point, spend a little time working on the willows and on the snow in the foreground.

9 Simplify Again
If you think the foreground snow is still too busy and distracting, use a mixture of white and Ultramarine Blue to repaint and simplify the entire foreground area.

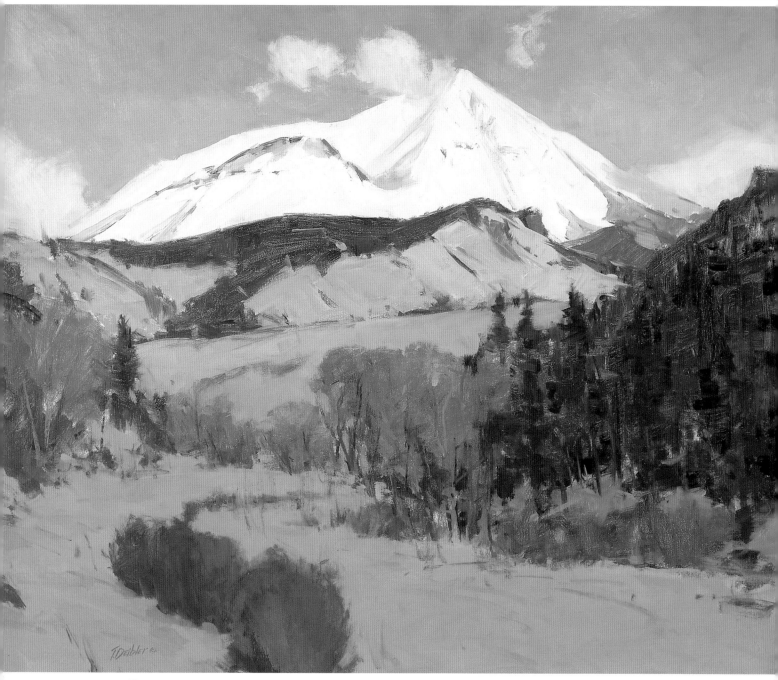

10 Pulling It Together

Step back and take a good look at the painting. If you are happy with it, you can stop; if not, decide what needs improving and add those final details. Sometimes it can be a struggle; however, these struggles are when your best learning occurs. Following is how I chose to finish the painting:

Not being able to get the snow the way I wanted it, I switched my concentration to the mountain. I added a shadow and a few more accents to give the mountain more of a sense of form. The edges on the cloud at the lower right seemed too rigid, so I softened them, making it feel more like a cloud. Taking a fresh look at the snow, I once again lightened it and tried to simplify it more. I decided to reshape the red bushes, giving them more of a random irregular shape. A suggestion of a rock and a few strokes representing twigs or grass help to keep the viewer's eyes from wandering off the edge. I added a hint of brush on the middle hill, and I reshaped the distant trees, making them a little more interesting.

The Gap—Winter • *Oil on linen* • *24" x 30" (61cm x 76cm)*

Painting Spring

■ Spring is full of contrasts. As nature awakes from its winter slumber we see the new colors of spring emerge from the fading colors of winter. This overlapping of seasonal colors often presents the artist with unusual and unique color combinations. This demonstration focuses on such seasonal changes.

We will begin this painting very directly with opaque paint from the start.

Reference photo

MATERIALS

24" x 30" (61cm x 76cm) Linen panel

PAINT
Phthalo Blue
Cadmium Yellow Light
Cadmium Orange
Naphthol Red Light
Ultramarine Blue
Titanium White

BRUSHES
Nos. 6 and 8 bristle flats

OTHER SUPPLIES
Charcoal or no. 2 pencil (optional)
Paint thinner
Paper towels

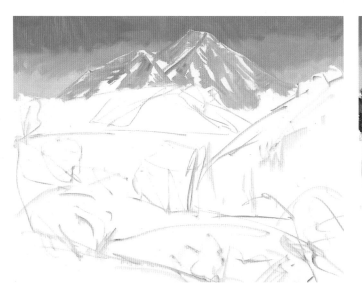

1 Outline Composition, Begin at the Top
Using a no. 6 flat and Cadmium Orange thinned with paint thinner, loosely sketch in the general shapes of your composition. You can use charcoal or even a no. 2 pencil to draw in the basic lines.

The direct painting technique can be started anywhere on the canvas, but for this demonstration we will start at the top and work down to the bottom of the canvas. The sky is a clear blue, painted with Phthalo Blue, Ultramarine Blue and white. Using your no. 8 flat, paint the sky darkest at the top, using more Ultramarine Blue, and lighter near the mountains, using more white. (I left the color transitions in the sky rather abrupt I will eventually blend them together as the painting develops.) Use mixtures of Ultramarine Blue, orange, red and white to paint the mountain, which is slightly warmer on the right side and cools as it moves to the left. Leave the snow patterns as unpainted canvas.

2 Warm and Cool Greens
Paint the green trees on top of the ridge with a mixture of Ultramarine Blue, orange, yellow and red. Keep the value darker than the mountain so the ridge will appear to be in front of the peak. Add a touch of white and yellow to the original mountain color mixtures and, still using your no. 8 flat, indicate the rock formations on the ridge. Use various warm and cool colors to paint the brush and grass slopes on the ridges. Since it's early spring, most of the ground cover still retains its winter color. Make a bright yellow-green by mixing Phthalo Blue and yellow and loosely brush it on to indicate the new leaves of the central cottonwood trees.

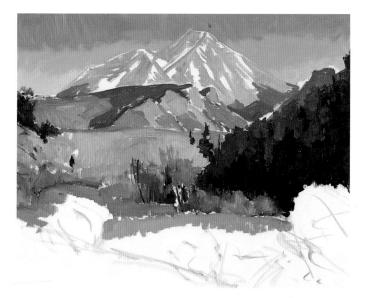

Add Darks

With very dark mixes of Phthalo Blue, orange, red and Ultramarine Blue, indicate the tree-covered slope on the right. Use more orange and yellow in the sunlit portions. Red, orange and Ultramarine Blue are used to block in the brush and bushes. Alternating between a no. 6 and a no. 8 flat, paint the trees, brush and grass. Don't fill in the entire canvas; allow some areas of white to remain between shapes. The important thing is that the entire range of values is established and that you can start comparing the values early on.

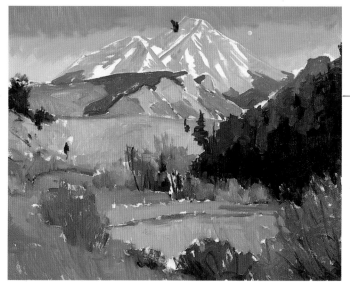

Cover the Canvas

Getting the rest of the canvas covered is your goal now, seeing all the important shapes working together. Using your no. 8 flat, paint the red willows with red and a touch of Ultramarine Blue, then surround them with a brilliant green of Phthalo Blue, yellow and white. Make the foreground bushes darker with mixes of Phthalo Blue, orange, yellow and Ultramarine Blue. The bare ground is orange, Ultramarine Blue and white. Having all the shapes, values and colors working together early on makes it easier to spot any elements that aren't working together.

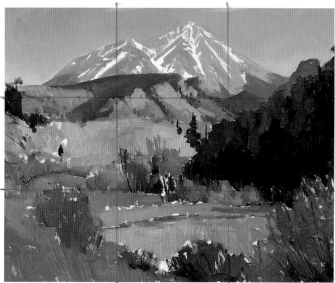

Soften Transitions

Starting once again at the top of the painting and still using a no. 8 flat, rework the sky making the color transitions smoother. Switch to your no. 6 flat, add a small touch of yellow to white and start applying paint to the snow patterns on the mountain. Alternate painting the snow and repainting parts of the mountain to reshape the snow. Paint the distant trees on the mountain slope a bluish purple with a mix of Ultramarine Blue, red, white and a touch of orange to keep it from being too bright. Once again using mixes of Ultramarine Blue, orange, yellow and red (see step 2), rework the trees on the ridge above the rock formations. A few more strokes are added on the rocks to get them nearer their final shape. Try not to spend too long on any area of the painting as you want to bring it up to completion all at the same time.

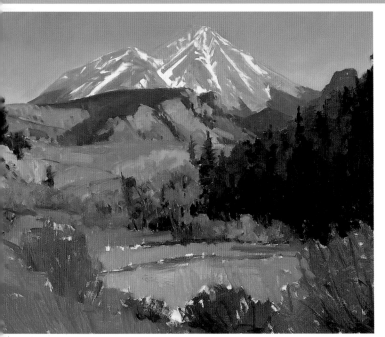

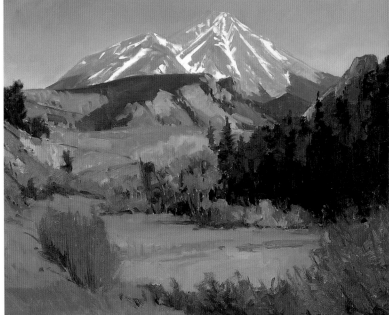

6 Think Spring

Work your way down, adding a variety of yellow-greens to the trees, and work additional dark strokes into the pine trees. Important seasonal colors you want to emphasize are the red color of the willows along with the bright green spring grass as well as the melting snow on the peak.

7 Start Finishing

Using the no. 8 flat and bright greens mixed with Phthalo Blue, yellow and white, bring the green grass more to the level of finish. A tan color mixed with orange, yellow and Ultramarine Blue is used to suggest the part of the field not covered with grass. The front bushes are suggested with various mixtures of all my palette colors, and the red willows are hit strongly with mixtures of red, Ultramarine Blue and very slight touches of yellow and orange.

8 Ask Yourself Questions

Now take a close look at your work. Are the snow patterns on the mountain convincing or do you need to make some changes? The addition of some tree trunks and branches with a mix of Ultramarine Blue and orange will help bring the trees to completion. Is the ground plane interesting or does it need to be broken up more? Step back and decide if you need to make any changes.

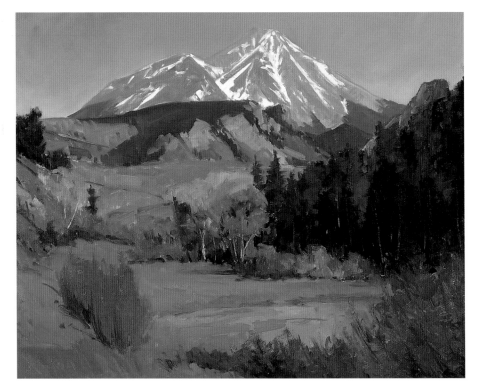

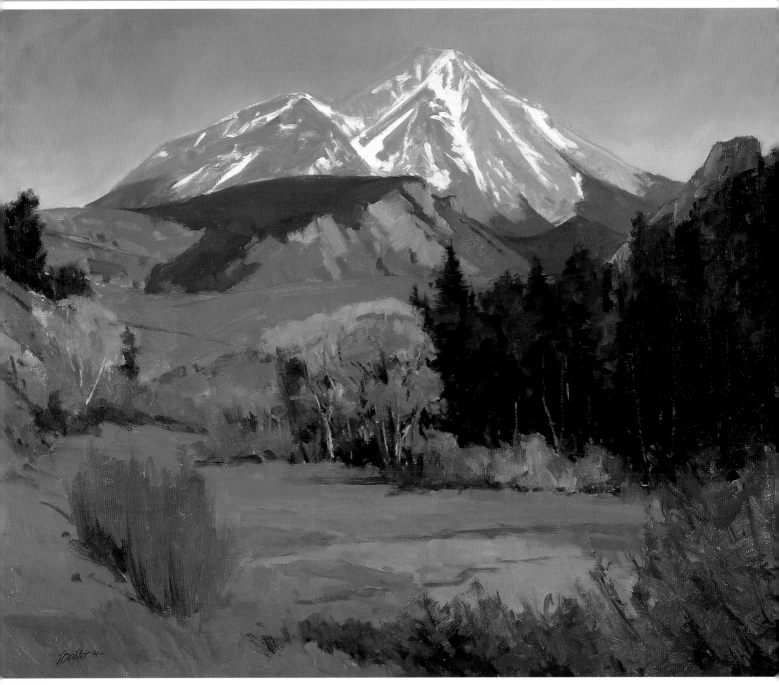

9 Touching Up

Again, I considered the painting finished in step 8, but as I looked at it closer I was still not pleased with the ground area, so I altered it once again to make it more interesting. The rock formations on the distant ridge seemed confusing, so I repainted them, simplifying them down into a more pleasing arrangement. I slightly altered the main snow pattern and added more tree trunks and branches before I finally called it finished.

The Gap—Spring • Oil on linen • 24" x 30" (61cm x 76cm)

Comparing the Seasons

Painting a favorite scene over and over can be a great source of inspiration as well as knowledge. Observing the same scene in a variety of changing conditions can impact the way we see nature and the way we express our vision through painting. We all have favorite places and memories and emotions attached to those places. The goal of these demonstrations is to show you some of the different possibilities available in the same subject. Not only did the seasons change in these four paintings, but also the time of day, lighting conditions and the starting method.

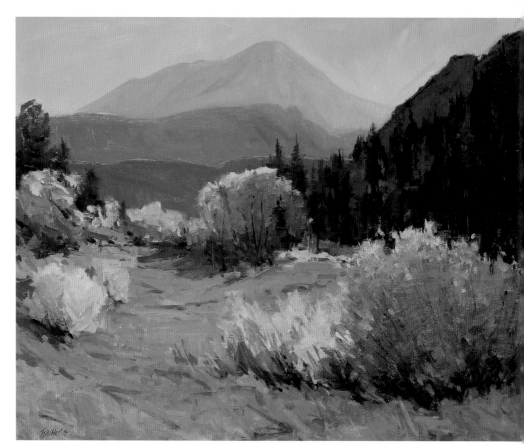

Autumn

Let's take a close look at the light. It's mid-morning in autumn and the sun is illuminating the foliage from behind. The mountain and hills are simplified as we look into the light, squinting to see.

The autumn example was carefully blocked in with many different transparent washes, approximating the final colors.

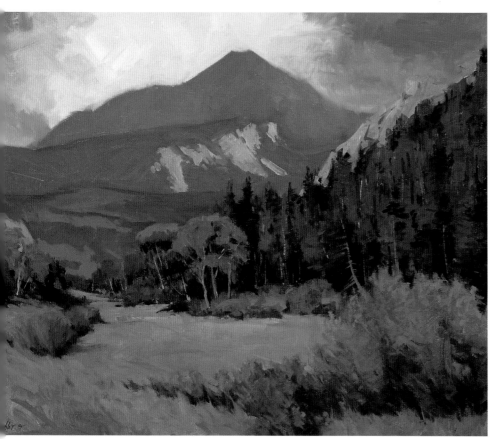

Summer

In this summer painting the sun is shining from the left, creating strong shadows in the foreground. A passing cloud casts its shadow over the peak making it appear as a simple mass. The various summer greens were first blocked in with red, the complement of green.

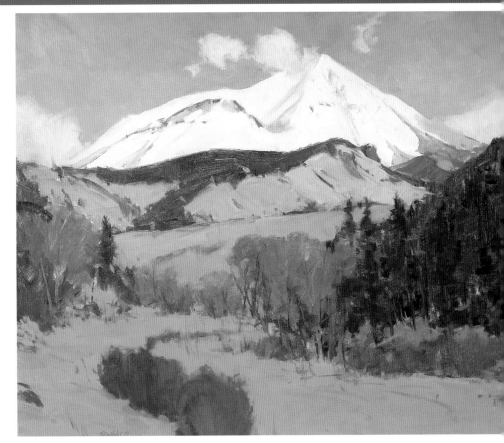

Winter

In winter the strong afternoon light fully illuminates the mountain peak, making it the center of interest.

This painting started very simply with orange to represent the sunny areas and blue to represent shadowed areas.

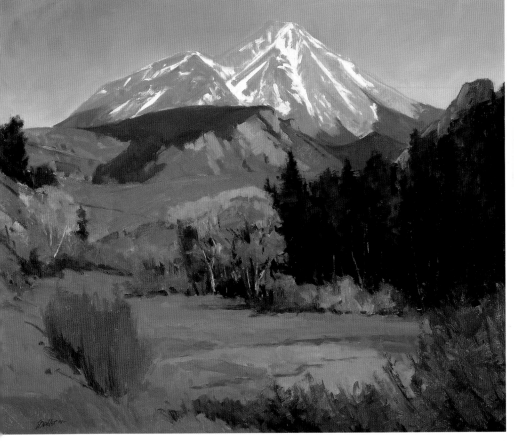

Spring

In this spring painting, the light is high in the sky and there are very few shadows, I relied on the interesting shapes and colors of the snow, hills and foliage to create a pleasing painting.

The painting was created using the direct painting method.

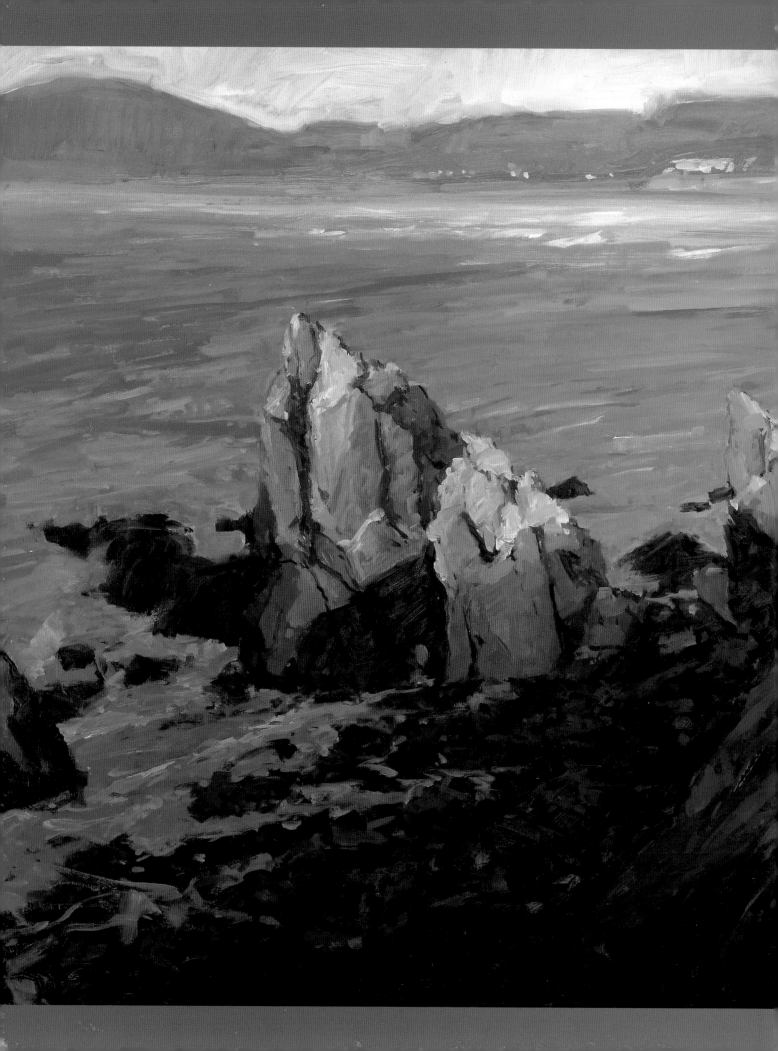

CONCLUSION

It is my sincere hope that this book has inspired you to continue in your pursuit of self-expression through painting. Persistence, determination, motivation and commitment are what make the artist, not talent. Every successful artist I know says it is hard work and not talent that has gotten them to where they are. The more you study and learn, the more you will realize that you haven't even scratched the surface of the knowledge available to you. Instead of calling this the conclusion, it should really be called the beginning.

Mankind has been creating since we were created. From the age of cave drawings to now, the need for self-expression continues. Study, learn and practice, practice, practice, then practice some more. Take the information I've presented here and use it as a starting point. We have the accumulated knowledge of the great artists from the past now available to us on the internet, at the click of a button. Visit museums and galleries and study the work of past and present artists and learn from their successes and mistakes.

Get outside and observe nature. Take the time to watch a sunset and notice how the color of the light affects the colors of the land. Watch the trees as their leaves undergo seasonal changes, or marvel at the intricacy of a single snowflake. Experience nature for yourself—then paint your experience.

Pacific Coast · Oil on Masonite · 30" x 40" (76cm x 102cm)

Index

The best in fine art instruction and inspiration is from North Light Books!

Master painter Kevin Macpherson shares his techniques for capturing the mood of a scene in bold, direct brushstrokes. His step-by-step instructions make it easy—simply a matter of painting what you see. In no time at all, you'll be creating glorious oil landscapes and still lifes that glow with light and color.

ISBN 1-58180-053-3, paperback, 144 pages, #31615-K

Here's the information you need to master the exciting medium of water-soluble oils! You'll learn what water-soluble oil color is, its unique characteristics and why it's generating so much enthusiasm among artists! Water-soluble oils make oil painting easier and more fun than ever before, plus you get gorgeous results. You may never go back to traditional oils again!

ISBN 1-58180-033-9, hardcover, 144 pages, #31676-K

Mastering basic brushwork is easy with Mark Christopher Weber's step-by-step instructions and big, detailed artwork. See each brushstroke up close, just as it appears on the canvas! You'll learn how to mix and load paint, shape your brush and apply a variety of intriguing strokes in seven easy-to-follow demonstrations.

ISBN 1-58180-168-8, hardcover, 144 pages, #31918-K

This book is for every painter who has ever wasted hours searching through books and magazines for good reference photos only to find them out of focus, poorly lit or lacking important details. Artist Gary Greene has compiled over 500 gorgeous reference photos of landscapes, all taken with the special needs of the artist in mind. Six demonstrations by a variety of artists show you how to use these reference photos to create gorgeous landscape paintings!

ISBN 1-58180-453-9, paperback, 144 pages, #32705-K

These books and other fine art titles from North Light Books are available at your local art & craft retailer, bookstore, online supplier or by calling 1-800-448-0915.